IMAGES OF ASIA

Chinese Almanacs

Series Editors, China Titles:
NIGEL CAMERON, SYLVIA FRASER-LU

Chinese Almanacs

RICHARD J. SMITH

HONG KONG
OXFORD UNIVERSITY PRESS
OXFORD NEW YORK
1992

3-28-93

Oxford University Press

Oxford New York Toronto
Kuala Lumpur Singapore Hong Kong Tokyo
Delhi Bombay Calcutta Madras Karachi
Nairobi Dar es Salaam Cape Town
Melbourne Auckland

and associated companies in
Berlin Ibadan

First published 1992
Published in the United States
by Oxford University Press, Inc., New York

Library of Congress Cataloging-in-Publication Data

Smith, Richard J. (Richard Joseph), 1944–
Chinese Almanacs / Richard J. Smith.
p. cm. — (Images of Asia)
Includes bibliographical references and index.
ISBN 0-19-585288-5
1.Alamancs, Chinese. I. Title. II. Series.
AY1144.S65 1992
032.02—dc20
92–16713
CIP

British Library Cataloguing in Publication Data

Smith, Richard J.
Chinese Almanacs. – (Image of Asia Series)
I. Title II. Series
030.951
ISBN 0-19-585288-5

Printed in Hong Kong
Published by Oxford University Press, Warwick House, Hong Kong

For Tyler

Preface

FOR hundreds of years almanacs (known variously as *lishu*, *tongshu*, *tongsheng*, *huangli*, and so on) have been among the most widely distributed publications in all of China. Even today, in environments such as Hong Kong and Taiwan, not to mention overseas Chinese communities and certain parts of the People's Republic, they continue to enjoy extraordinary popularity—despite the pervasive influence of modern science and the attractiveness of certain Western intellectual fashions. As a widespread and enduring feature of the Chinese social landscape for several centuries, they serve as a convenient measure of continuity and change, as well as an index of Chinese hopes and fears, aesthetic preferences, ethical concerns, and forms of symbolic expression. Perhaps no other single class of artifacts indicates more clearly and completely both the essence of China's inherited culture and the process of its evolution in late imperial and modern times.

Chinese almanacs stand at the meeting point of several major streams of cultural influence. One is, of course, China's ancient and highly sophisticated tradition of calendrical and astronomical science—itself a distinctively Chinese response to the universal need of societies to compartmentalize time and order space. Another is an equally long-standing interest on the part of the Chinese in various mantic arts, a topic I have treated at length in a recent book (see *Selected Bibliography*). A third is the persistent desire on the part of China's ruling class to structure Chinese political and social behaviour in every possible way, by every conceivable means—including the stipulations of official calendars and popular almanacs.

A salient theme of this small volume is the constant tension and interaction between elite and popular culture in China over the past two thousand years or so. The relationship between calendars and almanacs in many ways epitomizes this often-neglected phenomenon. But *Chinese Almanacs* is not simply an excursion into cultural history; it is also, and in fact primarily, an exercise in aesthetic appreciation. One important reason why almanacs have enjoyed so much popularity in China over the centuries is that they are visually appealing. Both in their covers and in their content they have constantly employed a colourful and powerfully resonant symbolism, deeply embedded in the consciousness of Chinese at all levels of society. These shared symbols—whether derived from nature, cosmology, history, the classics, or mythology—not only reflected, but also reinforced, certain features of the traditional culture, contributing to a remarkable sense of unity among Chinese everywhere. Although important changes have taken place in almanacs over time and space, it is their continuity in style and substance that catches our eye and commands our attention.

Contents

Acknowledgements

I would like to thank the librarians and staff members of the following research instititions for their invaluable assistance in helping me to locate and copy various calendars, almanacs, and related materials: The Beijing National Library; the Bibliotheque Nationale; the British Library (Oriental Manuscripts); the Cambridge University Library; the Harvard-Yenching Library; the Hoover Library (especially the James Hayes Collection) of Stanford University, the National Central Library in Taipei; the Library of Congress, Oriental Division; the University of Hawaii Library, the University of London's School of Oriental and African Studies; the East Asiatic Library of the University of California, Berkeley (especially the David Graham Collection); and the East Asiatic Library of the University of Washington, Seattle.

I am grateful to Carole Morgan and Sylvia Fraser-Lu for encouraging me to undertake this project; to Huang Yi-Long of the Institute of Historical Research, Tsing Hwa University (Taiwan), for allowing me to consult a number of his valuable, but as yet unpublished, writings in Chinese on almanacs and astrology; and to Wang Ming-hsiung, of Taipei, and James Hayes of Hong Kong, for their assistance in locating materials, and for sharing with me both their knowledge and their friendship. Thanks to Rice University for generous financial support, and to my wife, Lisa, for her sustained interest in my work, her valuable insights, and her editorial acumen.

1

The Relationship Between Calendars and Almanacs

A great deal of confusion exists in the rather sparse Western literature on Chinese calendars and almanacs. Most writers have failed to employ any sort of consistent terminology that distinguishes between these two types of works (Carole Morgan is a noteworthy exception). What some authors refer to as calendars, others describe as almanacs, and a number of Western writers use the two terms interchangeably, even when referring to the same basic publication. Although China's calendrical vocabulary is vast and often frustratingly ambiguous, meaningful distinctions can still be made. For our purposes, the term 'calendar' refers exclusively to an annual publication authorized and usually issued directly by the Chinese central government, while the word 'almanac' denotes an unofficial calendrical work which may be informally sanctioned, merely tolerated, or in fact expressly forbidden, by the State.

Historical Background

Part of the problem in differentiating calendars and almanacs stems from the close historic relationship between the two that has existed in China throughout the imperial era, from 221 BC down to AD 1912. Both works were based on solar days and lunar years, with an intercalary month inserted periodically to agree with the revolution of the earth around the sun. In each, the course of the sun was marked by 24 equal parts corresponding to the 12 divisions of the western

ecliptic. Although the Chinese government invariably produced at least one 'official' version of the calendar as a tangible sign of its right to rule (the so-called 'Mandate of Heaven'), popular almanacs based in part on the orthodox State model, but containing additional, unauthorized elements as well, circulated at the same time; and these works, in turn, influenced the imperial tradition of calendar-making.

From earliest times the Chinese calendar exemplified the notion of cosmological kingship. According to long-standing political beliefs in China, a sovereign had to understand the processes of change in the universe so as to assure that the social order and the natural way (*dao*), would be fully congruent. An inaccurate calendar, like the failure of designated officials to predict cosmic events such as eclipses, became a sign of moral imperfection, a warning that the monarch's virtue was not adequate to keep him in touch with celestial rhythms. Anomalies, including the gap between solar years (365.2422 days) and synodic months (29.53059 days), had to be reconciled, or at least explained. This accounts for the seemingly insatiable demand on the part of Chinese rulers for precision in calendrical calculations that far exceeded normal agricultural, bureaucratic, and economic requirements.

According to traditional mythology, Chinese calendrical science began with an order from the great sage emperor Yao (traditional reign dates, 2356–2254 BC), to the Xi and He families, commissioning them to 'fix the time' and pay respect to the celestial bodies (Fig. 1.1). This legendary event not only confirmed symbolically the astrological orientation of the ancient Chinese State, but it also attested to the critical role of the calendar as an index of political legitimacy. From the Shang dynasty (c.1500–1100 BC) onward, astronomical bureaux

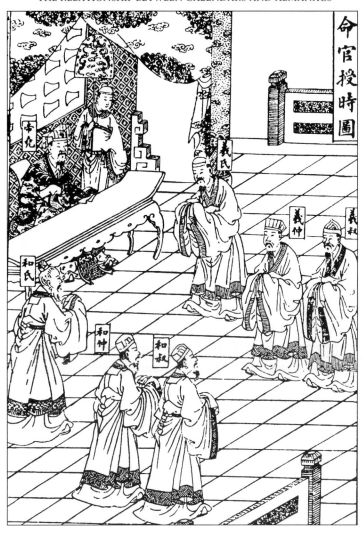

1.1. Emperor Yao commissioning the Xi and He families to 'fix the time'. From Joseph Needham, *Science and Civilisation in China*, Vol. 3, p. 187. Reproduced by permission of the Cambridge University Press. 19 cm. x 13 cm.

with different official names but similar administrative responsibilities, determined when the civil year of each dynasty or individual ruler would commence, and tried, with varying degrees of success, to reconcile the incommensurable calendrical interests of emperors, bureaucrats, farmers and philosophers.

The existence of such diverse viewpoints unavoidably led to the creation of specialized almanacs. Thus, while the official astronomical bureaux of each dynasty tried to monopolize production of the annual calendar, supervise astrological divination, identify lucky and unlucky days, and keep a record of auspicious omens and portents—all in the name of cosmological kingship—local almanac makers undertook similar responsibilities outside of, but often closely related to, this strictly defined sphere of imperial responsibility and control. During the Han dynasty (206 BC–AD 222), for example, predictive almanacs known 'day-books' (rishu) circulated among the élite and commoners alike. These early calendrical works, reflecting a growing popular interest in divination, designated certain activities as auspicious or inauspicious for virtually every day of the year. Significantly, the mantic system used for this sort of 'day-selection', known as jianchu, continued to be employed by almanac makers throughout the imperial era; and many of the specific religious and secular concerns of day-books—from the timing of sacrifices, planting, and travel, to the construction of earthworks and the making of clothes—can be seen in popular Chinese almanacs to this day.

At times, the imperial Chinese State made especially stringent efforts to monopolize astrological and calendrical matters. The emperors of the Tang dynasty (618–907), for instance, outlawed, with only a few minor exceptions, the private possession or use of any astrological charts or texts,

oracular works, or astrologically-oriented almanacs. Their efforts were, however, largely unsuccessful. Divination of all sorts flourished, and almanacs (*liri*) that predicted auspicious and inauspicious activities in the fashion of Han day-books became increasingly popular at all levels of Chinese society. Sometimes these inexpensive works were styled 'small calendars' (*xiaoli*) to distinguish them from the far more expensive and illustrious 'great calendars' (*dali*) of the State.

Furthermore, the invention and gradual spread of printing allowed enterprising entrepreneurs to begin producing relatively cheap but illegal versions of the official state calender itself, much to the consternation of Tang officials. In 835, the writer Feng Su complained that even before official promulgation of the new calendar, illicit printed copies had already found their way to market areas. 'This,' he wrote, 'violates the principle that . . . [the calendar] is a gift of His Majesty.' By the tenth century at the latest, the Chinese authorities began issuing special editions of the calendar for public consumption in an effort to pre-empt the production of pirated versions. Meanwhile, printed almanacs had also begun to appear in China. One of the earliest of these, now held in the British Library, bears the date of 877.

During the Song dynasty (960–1279), as printing and literacy developed apace, popular almanacs of all kinds proliferated. Affluent families sponsored some such compilations, while others seem to have been designed as direct (and presumably illegal) copies of the official State calendar. Still others were conceived solely as legitimate commercial ventures, undertaken by individuals or private publishing firms. Excavations from the caves of Dunhuang, in the desolate and remote north-western regions of the Chinese empire, reveal numerous examples of both handwritten and printed

almanacs that were produced and preserved in the period from the eighth to the tenth centuries. Many of these works, including a great number from the pre-Song period, correspond remarkably to the general format of almanacs in the present day (plate 1). We even have intriguing evidence of false starts, such as the hand-drawn Xingguo almanac of the Taiping era, dated 978, which includes depictions of the Great Year God (Taisui) surrounded by deities representing the 12 cyclical animals of the so-called Chinese zodiac.

At some point during the Yuan dynasty (1279–1368), the day-selection tables of popular almanacs became a regular and integral part of official calendars—a tradition that continued uninterrupted until the end of the imperial era in 1911. Although this development simply institutionalized a long-standing and classically sanctioned interest in day-selection on the part of China's emperors, later purists, such as Xie Dashen of the Ming dynasty (1368–1644) and Mei Wending of the Qing (1644–1912), argued that the selection of lucky and unlucky days for various activities lacked adequate calendrical precedent, and that the inclusion of day-columns in official calendars had the unhappy and detrimental effect of blurring the distinction between these noble works and the base almanacs of the popular masses.

Such criticisms indicate that to an unprecedented extent, the calendars of the Yuan, Ming and Qing periods resembled popular almanacs. Nonetheless, the imperial government steadfastly attempted to draw a clear line between the two, zealously guarding the emperor's sacred calendrical prerogatives. As in the past, an aura of magic surrounded the State calendar, and elaborate rituals attended its annual presentation to the emperor, as well as its distribution to nobles and officials. The *Collected Statutes* of each regime outlawed unauthorized reproductions, and official editions

of both the Ming dynasty's *Datong li* and the Qing dynasty's *Shixian li* (known after 1736 as the *Shixian shu* because of an imperial name taboo) carried explicit warnings to the effect that those who forged copies were subject to decapitation, and those who informed on such persons would receive an imperial reward of 50 ounces of silver (an ounce of silver or *liang*, was known to foreigners as a tael) (Fig. 1.2).

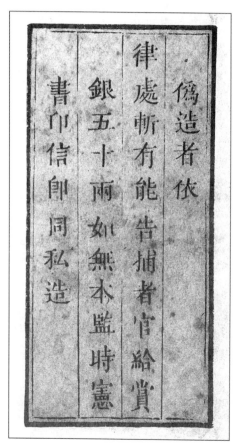

1.2. A calendar for 1745. On the back is the standard forgery warning. 13.5 cm. x 7 cm.

On the other hand, the high cost of State calendars for sale to the public—from 500 copper coins or 'cash' (each theoretically worth one thousandth of a tael), to well over a tael in the late Qing period (at a time when an ounce of silver would buy, say, 133 pounds of good quality rice)—made counterfeiting an extremely attractive proposition. As a result, pirated works styled *Shixian li* or *Shixian shu* circulated freely throughout the eighteenth and nineteenth centuries. As early as 1729 an edict issued by the Yongzheng emperor acknowledged the widespread publication of illegal 'private calendars' (*sili*) in southern provinces such as Jiangsu, Zhejiang and Fujian; and nearly a century later, the Jiaqing emperor in effect conceded defeat in the war against premature circulation of the calendar and the publication of pirated editions.

Meanwhile, almanacs (also produced primarily in the south, where printing was cheap) had come to provide an attractive, inexpensive and legal option to State calendars. Although lacking much of the prestige and mystical aura of their official counterparts, they cost only a fraction as much. Thomas Lister tells us that a 'stout' almanac of the 1870's could be bought for 'a few halfpence', and an extremely popular work by the celebrated Quanzhou (Fujian) almanac-maker Hong Chaohe, cost only 30 cash during the first half of the nineteenth century.

Naturally enough, sales boomed. Hong's relatives assert, for instance, that his almanac sold hundreds of thousands of copies, not only in China but also overseas. A report by the Society for the Diffusion of Useful Knowledge in China in 1838 referred to 'the almost universal demand . . . [for almanacs] among all classes of Chinese', echoing the views of many other informed contemporary observers. William Milne tells us that Chinese almanacs can be 'found in the

hands of every person, and on the counter of the commonest tradesman,' while Robert K. Douglas asserts that almanacs are 'eagerly studied by the educated among the people'. Most Qing fortune-tellers kept almanacs close at hand for reference (as they do to this day) (plate 2), and people from many other walks of life also relied heavily upon them. One late Qing ritual handbook indicates simply that 'no household is complete without an almanac'.

In order to enhance their prestige and increase sales, a number of almanac-makers in Qing times took pains to underscore the close connection between their own methods of calendrical calculation and those of the Chinese State. Some also included prefaces by local officials, designed to confer a kind of legitimacy upon them. These efforts made political as well as economic sense, for the Qing State invariably attempted to suppress any calendrical works that challenged its authority, regardless of what they were called. This was as true for the 'new calendar' (xinli) of the Christian-inspired Taiping rebels in 1853 as it was for the so-called Yongli calendar published during the 1670s by Ming dynasty remnants in south China.

Even works that made no pretence of being official might invite suppression, such as the early nineteenth century handbook entitled San Fo yingjie tongguan tongshu (Comprehensive Almanac for Responding to the Kalpas of the Three Buddhas [Past, Present and Future]). According to the Jiaqing emperor (r. 1796–1820), the rebel Lin Qing of the Eight Trigrams sect used this heretical document to 'deceive the people' and 'violate the authority of Heaven'. After discovering the almanac, the emperor ordered all copies destroyed and engaged in a relentless search for the authors and publishers. From the Chinese government's standpoint, to surrender calendrical authority of any sort to unorthodox

elements of society was to compromise the very foundations of imperial rule.

Shared Features of Calendars and Almanacs

Although precise astronomical and mathematical calculations have always provided the foundation for Chinese calendrical science, correlative cosmology occupied a central position in the construction of both State calendars and popular almanacs from the Han dynasty onward. The fundamental premise of this cosmology was an ordered universe in which the unseen forces of *yin* and *yang*, the so-called five 'phases' or 'activities' (*wuxing*, identified with the 'elements' earth, wood, fire, water and metal), the eight trigrams of the *Yijing* (Classic of Changes), the ten 'heavenly stems' (*tiangan*) and twelve 'earthly branches' (*dizhi*) of the ancient sexegenary numbering system, and a host of other cosmic variables— including both 'real' stars and 'star-spirits'—interacted with each other and resonated with 'like things' (*tonglei*). In this interconnected universe of cosmic resonance, fate was knowable. According to the *Yijing*, Heaven and Earth revealed themselves to human beings by means of celestial images as well as terrestrial forms. Patterns in the sky (*tianwen*), gave rise to a highly sophisticated tradition of Chinese astrology, while the existence of analogous earthly configurations (*dili*) encouraged the related pseudo-science of geomancy, often called *fengshui* (literally, 'wind and water').

In traditional Chinese astrology, star-spirits, designated either baneful (*sha*) or beneficial (*shen*), had special significance, for they determined whether activities would be auspicious or inauspicious at any given moment, in any given place. Most star-spirits did not exist as actual celestial bodies, but they nonetheless possessed tangible power. The influence

of a given star, whether manifest or invisible, depended on its relationship to other stars (whether in harmony or opposition), its phase (ascendant or descendant), the time of its apogee, and its correlative relationship to the five elements, and to the cyclical characters of the year in question.

The Great Year Star (Taisui), *yin* counterpart to the planet Jupiter, had special significance in determining the position of other positive and negative influences. Prohibitions relating to the compass points occupied by Taisui existed in China even prior to the imperial era, and by Qing times concern with Jupiter's regular 12–year rotation through the 28 segments of the heavens known as lunar lodges (*xiu*) invariably found expression in official calendars and popular almanacs. When situated in conjunction with auspicious star-spirits Jupiter brought good fortune, but in conjunction with baleful stars it brought misfortune. Like an astral emperor, if Jupiter's 'ministers' were good, peace and prosperity prevailed on earth; if not, calamities ensued.

Of the many schemes designed to depict stellar influences and relationships, the most commonly employed in the calendars and almanacs of late imperial times was the so-called Nine Palace (*jiugong*) system. In official calendars it appeared as a 'Diagram of the Position of the Spirits for the Year' (*nianshen fangwei zhi tu*; Fig.1.3) while in almanacs it was known as the chart of 'Important Affairs of the Year' (*liunian dali*), (plate 3). Each palace, representing the eight basic compass points plus the centre, housed a star-spirit for the year. By focusing on the movement of these spirits from year to year, one could determine auspicious and inauspicious directions for any given period. These considerations were of particular importance in Chinese geomancy, since earthly forms, whether natural or man-made, corresponded to, and therefore had to harmonize with, celestial patterns and

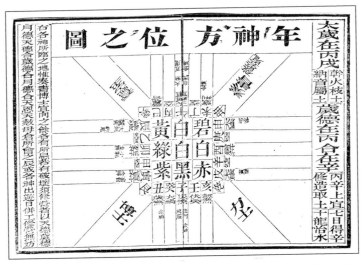

1.3. 'Diagram of the Position of the Spirits for the Year' from a calendar for 1886. 18.5 cm. x 12 cm.

powers. The primary purpose of *fengshui* was therefore to situate dwellings for both the living and the dead in harmony and in the proper position with respect to their immediate physical environment, and, by extension, the larger cosmos. The right location, and attunement with the primal forces of *yin* and *yang*, as embodied in 'material force' (*qi*), brought good fortune to everyone concerned, while disharmony obviously invited misfortune.

Although *fengshui* beliefs tended to be stronger and more widespread in south China than in the north, calendar-makers and almanac-makers during late imperial times included Nine Palace information in their publications as if geomantic beliefs were deeply and uniformly held throughout the empire. Not only did both kinds of works indicate star-spirit configurations for each year, but they also provided the

location of major positive and negative celestial influences—such as the Heavenly Virtue Star (Tiande; positive) and the Lunar Repression Star (Yueye; negative)—for every individual month. Thus one literally learned how to 'follow directions' at any given time. If the Way of Heaven (*Tiandao*) moved eastward, people understood that journeys should begin in a easterly direction; likewise, sedan chairs sent to bring a bride to her husband's home should go eastward initially; and buildings and repairs ought to be undertaken on the east side, if possible. By the same token, in the vertical columns that marked every day of the year, Chinese calendars and almanacs provided cosmologically-grounded advice on whether certain activities would be appropriate (*yi*; that is, auspicious) or inappropriate (*buyi*; inauspicious) (Fig. 1.4). Sometimes they even specified the proper hour for undertaking this or that affair. Although the dominant spirits operating on a given day were not necessarily specified in the text, every day-column indicated at a minimum the stem-branch combination that marked each day of the sexegenary cycle, as well as the associated element, lunar lodge and *jianchu* designation for that particular day. Calendrical calculations involving these variables were extraordinarily complex, and not always consistent, but overall the *jianchu* system played a pivotal role in determining the relative strength of specific spiritual influences for each day and therefore, the advisability of one or another activity.

The *Collected Statutes* of the Ming and Qing dynasties listed a wide range of activities to be classified as auspicious or inauspicious for any given day in calendars and almanacs. During the Qing period, 67 matters fell under the rubric 'imperial use' (*yuyong*) and 60 under 'almanac selection' (*tongshu xuanze*). Of the 67 categories of imperial concern,

1.4. Day-columns of a calendar for 1887. 19 cm. x 14 cm.

a number dealt with the specific responsibilities and prerogatives of the emperor and his designated agents: the promulgation of edicts, the bestowal of favours and awards (including amnesties, compensation, and titles), personnel matters (such as official appointments and the search for virtue and talent), diplomatic and military affairs, banquets, and so forth. The rest had to do with more mundane affairs, such as education, domestic rituals, travelling, moving, building, seeking health care, and even undertaking household chores. These latter activities were all included in the long list entitled 'almanac selection'.

The categories stipulated for 'almanac selection' included the following: sacrificing to ancestors, praying for good fortune, praying for a son, sending documents to superiors, being ennobled, sending a memorial to the throne, receiving an official appointment, inheriting noble rank, meeting with relatives or friends, starting school, 'capping' (a mark of adulthood for young males), travelling, taking up an official post, going on a tour of inspection and mingling with the people, undertaking various marriage ceremonies (several separate categories are mentioned here), adopting a child, changing residence, setting up a bed, getting rid of things, taking a bath, shaving the head, clipping fingernails and toenails, seeking medical treatment, caring for the eyes, sewing or embroidering, cutting out clothes, building a dam, breaking ground for a building, erecting pillars and setting up roof beams, building or repairing a storehouse, working metal, using a grass thatch, weaving silk, reopening a business, issuing bonds, doing business, opening a storehouse, selling goods, buying or repairing property, cutting a canal, digging a well, setting up a treadle-operated pestle (for grinding grain), mending walls and repairing holes, sweeping the floor, decorating walls, levelling roads, pulling down a house,

demolishing a wall, cutting lumber, catching animals, hunting game, fishing, crossing a river by boat, planting, herding or tending animals, breaking ground for burial, burying the dead, and beginning to save money.

Most of these activities appeared only rarely in calendars and almanacs. That is to say, the vast majority of days were 'neutral' for most officially-stipulated undertakings. The activities most commonly listed as auspicious were those pertaining to routine domestic sacrifices and regular household duties, while those appearing most frequently as inauspicious for any given date were associated with some sort of disruption in daily routines—notably travelling, (by far the most commonly discouraged activity in both calendars and almanacs), planting, and breaking ground for a building. A comparatively large number of days were also considered inappropriate for sewing. Although some days of the year had no activities at all designated as lucky or unlucky, a majority of day-columns contained several activities, the bulk of them auspicious.

Since many almanacs deliberately took as their model imperially-authorized sources of cosmological authority, they tended to approximate State calendars in the days and times for which activities might be designated either auspicious or inauspicious. The State, for its part, encouraged this tendency. An edict of 1728, for instance, mandated that certain 'joyous' activities such as births and marriages must not be included in the day-columns of almanacs if they happened to fall on the death date of a former emperor or empress. But calendars and almanacs still did not always agree in particulars. If, for example, we compare one version of the official calendar for 1857 with a work such as the *Bianmin tongshu* (Almanac for the Convenience of the People) for the same year, we find that whereas the calendar

designates the fourth day of the first month as inappropriate for travel, the almanac lists the third as inauspicious for this purpose and not the fourth, and although both works indicate that the ninth day of the first month is auspicious for sacrifices, only the calendar specifies that it is not a good day to travel.

One might ask, then, how seriously did the emperor and his subjects take the stipulations of calendars and almanacs? It is difficult to say. Presumably the popular masses were more susceptible to such beliefs than scholars, if the remarks of Xie Dashen and Mei Wending are any indication. In the view of Alfred Lister, a knowlegeable Westerner writing in China during the 1870s, the primary appeal of popular almanacs was precisely the advice contained in their day-columns. He tells us: 'The great use [of Chinese almanacs] is to choose lucky days, to divine on what days undertakings may be begun, and when they had better be left alone.' Similarly, the well-known missionary-scholar S. W. Williams writes, 'No one [in China] ventures to be without an almanac, lest he be liable to the greatest misfortunes, and run the imminent hazard of undertaking the important events on black-balled days.'

Bureaucrats, too, seem to have followed the stipulations of day columns, at least on occasion. The writings of foreigners in the Chinese service, from Matteo Ricci in the early seventeenth century to Robert Hart in the late nineteenth, testify to a firm and pervasive belief in lucky and unlucky days on the part of Ming and Qing officials, not to mention their frequent recourse to State calendars for guidance. One such Western employee, W. A. P. Martin, remarked: 'No man [in China] thinks of beginning a journey, laying a corner-stone, planting a tree, marrying a wife, burying a parent, or any of a thousand functions in public or private

life, without consulting this convenient oracle.' A. P. Parker, another well-informed Westerner, offered a similar view: 'The astrological part [of the Chinese calendar] is universally believed in, though there seems to be considerable difference in the practice of the details by different persons, some considering it necessary to be careful about the times and places of carrying out the most important affairs of life, such as marriage, burial, house-building and so on, while others believe it necessary to be careful as to the time and place for the most commonplace details of everyday life, such as opening a shop, entering school, going on a journey, giving an entertainment, sweeping the floor, shaving the head, taking a bath, and such.'

Significantly, the cosmology of Chinese calendars and almanacs, as expressed in day-columns and other shared features of these works, remained virtually unchanged until 1911. In that year, however, the Qing dynasty fell to Republican revolution, and State-sponsored cosmology suffered a mortal blow. From this point onward, the two types of publications took radically divergent paths. On the one hand, the new State calendar of the Republic for 1912 adopted the Western Gregorian model and vigorously denounced the 'superstitious' elements of its predecessor, including the stipulation of lucky and unlucky days. On the other, popular almanacs continued to reflect the inherited cosmology with a vengeance. Before considering more carefully the issues of continuity and change raised by these developments, let us give more systematic attention to the Qing period, which provides the necessary background for an understanding of the modern era.

2

Qing Dynasty Almanacs

DESPITE their close historical relationship and shared cosmological assumptions, the calendars and almanacs of Qing dynasty China differed in several fundamental respects. In the first place, calendars alone went by the designation *Shixian li* or *Shixian shu*, its post–1736 counterpart. Their format was rigidly fixed by statute, and limited almost exclusively to stark day-columns, temporal charts and cosmic diagrams. Almanacs, by contrast, were subject to few formal restraints. In fact, the vast majority managed to include, in addition to standard day-columns, charts and diagrams, numerous woodblock illustrations and a variety of colourfully written texts, from classical-style prose and poetry to vernacular stories and simple verse. Furthermore, their production and distribution involved none of the ceremonial fanfare connected with formal State publications. Although many people assumed that almanacs possessed some sort of magical power, they were not in any sense sacred in the fashion of State calendars.

The Basic Features of Qing Almanacs

Almanacs of the Qing period generally boasted auspicious red covers rather than imperial yellow ones, and they went by a bewildering variety of titles. Some names were cheerfully optimistic, such as the *Jixiang ruyi tongshu* (Almanac for All the Good Luck You Could Want); others were more down to earth: *Guanshang kuailan* (A Quick Reference for Officials and Merchants); *Riyong bianlan* (A Handy Reference for Daily Use); *Xuanze tongshu* (Almanac for Choosing [Lucky Days]),

19

and so forth. A number bore the name of an auspicious-sounding place of publication, such as 'The Hall of Riches and Honour' (Fugui tang) or 'The Hall of Advantage from Literature' (Liwen tang); and many contained terms designed to indicate comprehensiveness (*daquan*). By the late Qing period a number of these publications, like official calendars, had prefixes warning of possible penalties for pirated versions.

As indicated above, almanacs included a great deal of material not expressly stipulated in the Qing *Collected Statutes*. Their day-columns, for example, commonly ident-ified the location of 'womb spirits', so that pregnant women could avoid miscarriages and birth defects by staying away from those parts of the house (front gate, pestle, mill, chicken coop, kitchen, stove, bed, storage area, toilet, and so on), where such spirits might be present at a given time. On the page designated 'Important Affairs of the Year', which corresponded to the official calendar's 'Diagram of the Position of the Spirits for the Year', one could always find one or two small boxes with counsel from the so-called 'Earth Mother'. This advice, never to be found in calendars, consisted of excerpts from a prognostic work entitled the *Dimu jing* (Earth Mother Classic) pertaining to agricultural prospects as well as those of sericulture and animal husbandry.

Interestingly enough, this information did not always agree with that provided by the other major source of agricultural prognostication in almanacs—the 'spring ox' (*chunniu*) and its 'herdsman' (*shentong* or *mangshen*), (plate 4). Although woodblock representations and/or written descriptions of the ox and herdsman appear in every almanac I have ever seen, they are never depicted in official calendars. In fact, their very presence on the pages of a document entitled *Shixian li* or *Shixian shu* indicates that the work in question is undoubtedly a pirated version, despite its otherwise orthodox appearance.

According to popular belief, the colours of the spring ox and the clothes of the herdsman indicated agricultural and other prospects for the coming year. But the precise meaning of this symbolism varied. By one Qing account, a predominance of white portended floods and rain; red suggested fire and heat; green, strong winds and storms; black, disease; and yellow, a bountiful harvest. Another otherwise similar version invested the colour green with the meaning of conflict. Still another indicated that if the head of the ox were yellow, then there would be great summer heat and if green, there would be much sickness in the spring. If red, a drought would come; if black, much rain; and if white, high winds and storms.

In fact, the symbolism of colour and attire had nothing to do with actual meteorological observations. Rather, it was based on traditional cosmological calculations involving *yin* and *yang*, the five elements or 'agents', and the so-called heavenly stems and earthly branches, which in various combinations marked cycles of 60 days and 60 years. If, for example, *yang* governed a certain year, the mouth of the ox stood open; if *yin*, it remained closed. For those years marked by the stems *jia* and *yi*, the head of the ox would be green; for those marked by the branches *yin* and *mao*, the body would be green, and so forth. The same kind of calculations yielded the colour of horns, hooves, neck and tail, as well as the specific features of the herdsman. Although this symbolism might admit of somewhat different interpretations, and was in any case, of no real value to farmers, its periodic expression in almanacs reaffirmed the importance of agriculture in Chinese society and contributed to a shared sense of culture at all levels.

In addition to purely symbolic material of this sort, almanacs also contained genuinely useful information.

Most had fairly reliable data on seasons, tides, and local times, for instance. Many also included entries on different categories of food and/or various kinds of medical prescriptions. Some remedies were designed to cure colds, counteract snakebites, and take care of common health problems such as foot ailments, nosebleeds, and toothaches. Others dealt with more specific maladies, such as a woman's failure to lactate after giving birth to a child. Sometimes, the practical advice in almanacs even extended to sex. Thus we find in a number of almanacs produced in the Guangzhou (Canton) area of south China, and dating from at least the early nineteenth century, a long section entitled 'Methods for Producing Children' (*Zhongzi fangfa*).

This section contains surprisingly explicit (but not very accurate) information for women and men concerning menstruation, times for and frequency of sexual intercourse, preparations for pregnancy, and so forth. These discussions, which included prescriptions for regulating menstruation, strengthening vital essence (*jing*), and consolidating pregnancy, indicated that while the birth of sons or daughters was fundamentally a matter of Heaven-conferred fate, human action could, after all, influence events. Thus, for instance, if a husband and wife wanted a healthy male child, they should be rested before having intercourse. They should choose a quiet time, on a *yang* day and at a *yang* hour, and avoid eating dog meat. After intercourse, the woman should lie on her left (*yang*) side.

Ethical concerns loomed large in most Qing almanacs. Even when these works offered advice regarding private matters, such as sex, they tended to focus on moral considerations—or at least themes of moderation and self-restraint. Thus, a *Daquan tongshu* (Complete Almanac) for 1819, informed husbands that if their wives were to

have healthy children, they must curb their selfish desires. They should not force themselves upon their spouses, have intercourse too frequently, or engage in sexual activity while drunk.

Most almanacs contained morality tales. Perhaps the most common set of stories, which circulated at all levels of Chinese society in Qing times, was the 'Twenty-four Paragons of Filial Piety' (*Ershisi xiao*; Fig. 2.1). Each anecdote, usually illustrated with woodblock prints and explained in a few lines of text, depicted a virtuous individual whose act of devotion to a parent epitomized self-sacrifice. Among the 24 exemplars were individuals such as Wu Meng, who encouraged mosquitoes to feast on him instead of his parents; 'Old Laizi', who at the age of 70 amused his parents by pretending to be a child; Huang Xiang, who dutifully fanned his father's pillow in summer and warmed his bed in winter; and Guo Qu, whose willingness to sacrifice his only son in order to have enough resources to care for his mother provided a rationale for infanticide in late imperial times.

Although the moral world of Chinese almanacs rested solidly on orthodox Confucian values, these values sometimes appeared in Buddhist or Daoist dress. An almanac for the year 1873 includes, for example, stories of karmic retribution in which unfilial daughters-in-law are transformed into lower animals in their next reincarnation as punishment for their shameful behavior. Another indication of the religious orientation of many Qing almanacs is their inclusion of charts listing the 'birthdays' of literally dozens of deities from both institutional religion and the pantheon of folk belief. Among these overlapping categories of personalized spirits are deified historical figures such as Confucius, Hua Tuo, Guan Yu and Yue Fei; Buddhist gods and goddesses (notably Amitabha, the Maitreya Buddha and Guanyin), and a great number of popular

spirits, such as the Jade Emperor, Zhang Daoling (also known as Zhang Tianshi), Tianhou (Consort of Heaven), and the so-called King of Hell.

2.1. Wu Meng, one of the 'Twenty-four Paragons of Filial Piety'. From an almanac for 1876. 16.5 cm. x 11.5 cm.

Knowing Fate

Unlike calendars, which depersonalized the world of spirits and confined their divinatory prescriptions primarily to Nine Palace charts and day-columns, almanacs personalized almost everything, presenting a great range of mantic options and a far more individualized approach to the future. One common device for 'knowing fate' was the 'Emperor of the Four Seasons' (*Siji huangdi*), whose head, body, arms and legs bore characters representing the 12 heavenly stems, which, when not used in combination with the 10 earthly branches, indicated one of the 12 two-hour segments of the 24–hour day. These characters were explained by 56 accompanying verses of five characters each. When a child was born, the parents consulted the appropriate figure for the season to discover what the future held for anyone born in any particular two-hour time period. On the whole, a birth time located on the head, hand, shoulder, belly and groin were fortunate, while one on the leg or foot was less auspicious.

Similar indications of one's fate could be found in other sections of the almanac. One simple illustration showed the influence of the five 'elements' or 'activities' on a child's personality. Another depicted the dominant asterisms of each of the 28 lunar lodges, suggesting in a more substantial way the effect of each star system on a person born under its influence. Each asterism, (constellation), had a name, a five agents correlation, and an associated animal, and each was personified by a heroic figure from Chinese mythology (depicted, like the stellar configurations, in an illustration accompanying the written text). The asterism Jiao, for example, was correlated with wood, the hornless dragon, the warrior Deng Yu, and good fortune.

As signposts to the future, almanacs almost invariably included depictions of the 26 or so dangerous 'passes' (*guan*) encountered by Chinese children as they grow to adulthood. Most such barriers had colourful names: The Four Pillars, White Tiger, Heavenly Hound, Deep Water, Metal Chain, Five Demons, Down the Well, Buddhist Monk, King of Hell, Hanging from the Heavens, Four Seasons, Water and Fire, Nocturnal Cries, Flying Rooster, Washtub, Broken Bridge, Quick Foot, Iron Snake, and so on. The basic premise was that birth at certain times, in certain months, made a child particularly susceptible to one or another hazardous situation. These situations, which differed slightly from almanac to almanac, ranged from relatively common dangers (deep water, burning broth, falling into a well, and so on), to more frightening encounters with generals, demons, tigers, and even the so-called King of Hell. Some hazards were represented metaphorically rather than literally, so that an illustration of an encounter with a snake actually signified exposure to a disease, such as measles, rather than a confrontation with a dangerous animal.

Almanacs also provided a number of techniques by which individuals could divine for themselves. One of the most popular involved a rudimentary system of counting on finger joints called 'hitting the time' (*dashi*). Calculations regarding the month, day and hour of an event were made on the six main joints of the three middle fingers of the left hand. By adding in succession the numbers of the month, day and hour of a given occurance, a person could arrive at one of six major predictions. An 'explanation' would then follow, predicting the outcome of situations having to do with matters such as seeking wealth, losing things, domestic issues (including marriage and pregnancy), travel, trade, illness, military affairs, and litigation. A closely related but more complex technique of finger calculation divided the fingers of the left hand into

12 segments—four each for the index finger and small finger, and two for each of the middle two fingers.

Most almanacs provided texts to be used in conjunction with divining blocks (*jiaobei*) and 'spiritual sticks' (*lingqian*). Divining blocks were paired pieces of wood or bamboo root from three to five inches in length, generally carved into the shape of a crescent moon with one side flat and the other convex (plate 5). Dropped together, usually in front of a deity, they could yield three possibile combinations. Based on these possibilities, a divination system developed in which various combinations of three throws yielded fixed answers to 28 sets of circumstances organized according to the lunar lodges of Chinese astrology. As with the hand calculation techniques mentioned above, the most common categories of concern were money, movement, domestic life, health, lawsuits, and lost articles.

Spiritual sticks, (a favourite divining technique of Chinese temple worshippers in Qing times, and still popular in Hong Kong and Taiwan), came in sets that varied in number from 20 to more than 100. The sticks themselves, each about 12 inches in length and numbered consecutively, rested together in a bamboo tube (plate 6). When a person sought to use them as a means of seeking divine guidance, he or she would shake the tube until a single stick emerged further than the others. The number of this stick referred the person to a terse written message in poetic form. At most temples, religious functionaries helped illiterates to interpret these cryptic oracles, but for those who could read, *lingqian* booklets, often reprinted in almanacs, provided explanations and elaborations. A typical explanation might read: 'You will attain merit and fame. Your blessings and wealth will be complete. [If you are involved in] litigation you will obtain a proper settlement. If sick, you will become well. [If you are a farmer] your crops [literally mulberries and hemp] will

ripen fully. Your marriage [will be satisfactory]. Pregnancy will yield a son. Travellers will return home.'

Virtually all Qing almanacs included a section on personal omens, since portents played such a significant role in all aspects of Chinese life, at all levels of society. The standard categories were: twitching of the eyes, ringing in the ears, a burning or itching sensation on the face or ears, quivering flesh, palpitations, sneezing, clothes askew, the sounds made by a hotpot on the stove, a fire growing out of control, a dog barking, and a magpie chirping (Fig. 2.2).Timing was critical to correct interpretation, and thus almanacs invariably divided their omen categories into 12 standard two-hour periods marked by the 'earthly branches'. A ringing in the left ear at the *chou* hour (1 a.m.–3 a.m.), for example, signified a quarrel, and in the right ear, a lawsuit. As with *qian* slips, most of the omen texts contained in Chinese almanacs were favourable, and the majority dealt with down-to-earth themes: visits from friends, relatives and others (including Buddhist and Daoist clerics), feasting, and the accumulation of wealth. Unfavorable events included injuries, disputes, lawsuits, and the loss of money.

Qing almanacs frequently provided information on dream divination culled from a highly influential work entitled *Zhougong jiemeng* (The Duke of Zhou's Explanation of Dreams). The most extensive version of this work consists of about one thousand dream interpretations, each reduced to a pithy seven-character phrase. Most of the entries in the *Zhougong jiemeng* are positive, phrased in the following way: 'When the skies are clear and rain has dissipated, all worries will disappear' and 'When one rides a dragon up to Heaven, great honour will follow'. About a third of the interpretations, however, carry negative connotations: 'If a star descends from the heavens, there will be illness and lawsuits', 'If the sun or moon descends from the sky, a parent will die'. The most common desires expressed in

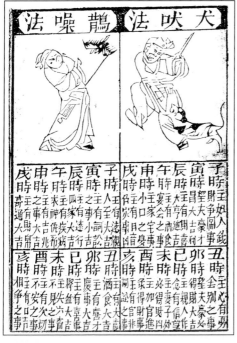

2.2. Omens: a dog barking and a magpie chirping. From an almanac for 1848. 16 cm. x 11 cm.

the *Zhougong jiemeng* are for good luck, wealth, health, high position, honourable children (particularly sons), and longevity. The greatest fears are death, illness, violence, poverty, lawsuits, and the usurpation of authority.

Shorter versions of the *Zhougong jiemeng* included in popular almanacs usually bore the title 'Books of Good and Bad Fortune [Based on the Duke of Zhou's] Explanation of Dreams'. These truncated works might have only a half dozen or so categories and only about 100 or so seven-character interpretations. *The Daquan qizheng tongshu* (Comprehensive Almanac Based on the Seven Regulators) of 1858 provides a typical example. It has a total of 118 stanzas divided into sections on heavenly patterns (19 entries), earthly

configurations (9 entries), spirits (9 entries), the body (19 entries), sorrow and joy (9 entries), hitting and cursing (9 entries), and miscellaneous (44 entries), most of which deal with officialdom, domestic life and structures, plants and animals . On the whole, both the specific interpretations and the ratio of auspicious to inauspicious dreams in these 'Books of Good and Bad Fortune' correspond closely with the full-length *Zhougong jiemeng*.

Much of the divinatory information contained in almanacs revolved around the time of a person's birth. As is well known, every newborn child in China, male and female, automatically became linked with a 'zodiacal' animal for that year. Each animal correlated with the earthly branches in repeating cycles of twelve: the rat, ox, tiger, rabbit, dragon, snake, horse, sheep, monkey, rooster, dog and pig. According to popular belief, as invariably expressed in almanac charts, individuals born in years marked by antagonistic animals should not marry. According to one scheme, the horse and the ox were bad for each other, as were the sheep and the rat, the rooster and the dog, the tiger and the snake, the rabbit and the dragon, the pig and the monkey. Another system, however, pitted the rat against the horse, the ox against the sheep, the tiger against the monkey, the rabbit against the rooster, the dragon against the dog, and the snake against the pig.

In any case, marriage negotiations in Qing China took into account far more than simply the year in which a person was born. At the very least matchmakers considered the 'eight characters' (*bazi*) that marked the year, month, day and hour of birth of each person—particularly since the most popular form of divination in late imperial times placed primary emphasis on the day.

Almanacs contained several *bazi*-related systems of divination, in addition to tables of marital compatability.

One of the most common was called 'The Conferral of
Blessings by the Heavenly Official' (*Tianguan sifu*), (Fig. 2.3,
plate 7). It consisted of a rectangular chart, surrounded by
characters and illustrations representing the five planets and
various other 'stars' or star-systems, and subdivided into
sections corresponding to the 12 earthly branches. Each
section, called a 'palace', indicated the major celestial
influences operating on a person born at a particular time.
This highly individualized system of fate calculation was
clearly related to, but did not necessarily coincide with, the
more general and predominant Nine Palace system of
orthodox calendrical cosmology.

Most almanacs had one or more circular charts known as
zhoutang, consisting of the *yin-yang* symbol (*Taiji tu*)

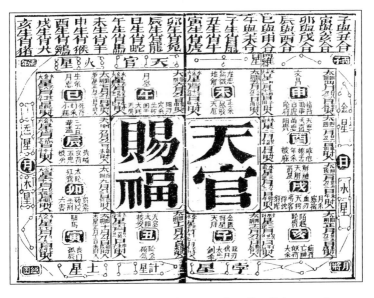

2.3. 'The Conferral of Blessings by the Heavenly Official', from an almanac
for 1876. 18.5 cm. x 14 cm. See also plate 7.

surrounded by a certain number of special characters used in calculating the proper time for undertaking various ritual activities, such as transferring a bride to her husband's home, changing the place of a sick person's bed, burning incense and paper money, or undertaking ceremonies related to burial of the dead. Mortuary ritual had special significance because of its close relationship to geomancy (*fengshui*). This widespread belief in the harmonious siting of buildings and other structures, invariably entailed the consultation of almanacs, as J. J. M. De Groot, a close and reliable observer of Chinese customs in the waning years of the Qing dynasty, indicates: 'The chief use of the geomantic compass', he writes,' is to find the line in which, according to the almanac, a grave ought to be made, or a house or temple built. Indeed . . . in this most useful of all books it is decided every year between which two points of the compass the lucky line for that year lies and which point is absolutely inauspicious.'

Sometimes magical charms, (*fu*), could counteract an inauspicious location or bad timing. They could also provide protection against evil spirits. These talismans consisted primarily of paper 'orders' written as if from superiors to inferiors. As a rule they contained the character(s) meaning 'a command', as well as various other characters (and amalgams of characters) connected with authority (sages and generals), natural phenomena (the sun, the moon, mountains, fields, thunder, and so on), and of course, the supernatural (demons, good and evil star-spirits, and such). Most almanacs included at least one general 'stabilizing' charm and one designed to protect an unborn child, and many boasted several sets (plate 16).

Efforts in the early nineteenth century by Protestant missionaries and their Chinese converts to produce almanacs devoid of 'superstitious' elements, such as charms, divination

techniques and the designation of lucky and unlucky days, never gained a significant readership. Even after Western ideas began to penetrate China more thoroughly and systematically following the Opium War of 1839–42, virtually no new information found its way into almanacs for several decades. Only after 1895, with the trauma that attended the Sino-Japanese War, did Qing almanac-makers find it either desirable or necessary to depart from time-honoured models.

The Introduction of New Elements

Defeat in the Sino-Japanese War of 1894–5 shattered China's sense of cultural superiority, and initiated a period of intensive borrowing from both Japan and the West. This, in turn, contributed to rapid political, economic and intellectual changes. Almanacs reflected the changing times—albeit more slowly than the times themselves were changing. By the end of the nineteenth century, almanacs had become valuable conduits for information of all sorts, foreign and domestic. Almanacs for 'officials and merchants' were especially popular at this time, no doubt because so many of the changes in the late Qing period had to do with the related realms of administration and commerce.

These publications, now sometimes styled 'new almanacs' (xin tongshu), at once expressed and contributed to an evolving awareness of China's new international and domestic circumstances. Increasingly we find, in addition to the usual wealth of cosmological and divinatory detail, a modern map of China, photographs of Chinese political leaders such as Prince Qing, and lists of recently established institutions, offices, and titles (Fig. 2.4). Some late Qing almanacs gave particular attention to Japan, supplying valuable data on place names and locations, as well as rather

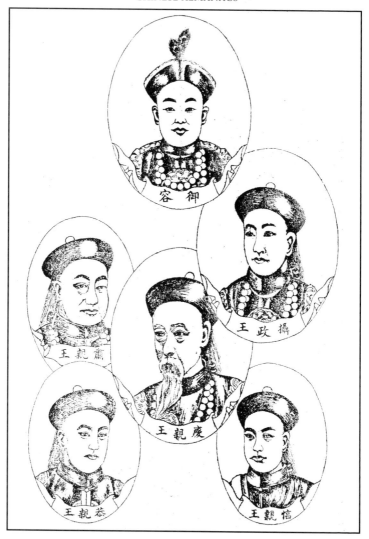

2.4. Portraits of Manchu political figures from an almanac for 1908. 20.5 cm. x 13.5 cm. The older individual in the centre is the notorious Prince Qing, chief Grand Councillor of China from 1903–11.

arcane information, such as a list of pre-Meiji Japanese emperors. Even almanacs designed primarily for specific local audiences, such as the popular version published by the Mansion of Heavenly Treasure (*Tianbao lou*) in Guangzhou for Cantonese readers, began to reflect a more cosmopolitan outlook in their now expanded editions. In 1905, for instance, the *Tianbao lou* almanac showed pictures of China's new national flags as well as the flags of various foreign nations such as England, France, Russia, Germany, and Japan (Fig. 2.5).

That same year, the *Yingxue zhai fenlei guanshang bianlan* (Topical Guide for Officials and Merchants from the Study of Dazzling Snow), published in Shanghai, made a special point of emphasizing that it contained no less than 700 specific categories of information—200 more than the previous year. Some of this material remained standard for virtually all Qing almanacs; and some of it represented nothing more than the opportunistic appropriation and updating of information traditionally supplied by 'encyclopaedias of daily use' (*riyong leishu*), such as information on Chinese ritual forms, commercial affairs, civil and military administration, forms of address, styles of correspondence, types of food, dress and medicine, and so on. But much of the content of these 'new almanacs' reflected growing interest in Japan and the West.

In fact, the preface indicates explicitly that in addition to following traditional calendrical models, the almanac also includes new information on Western culture because 'the mood of [the people] has gradually opened up to the idea of Sino-foreign contact'. Reflecting a decidedly treaty-port perspective on Chinese life, in the preface, the publishers claim to have incorporated this new information not only because businessmen and officials need to know how to deal more effectively with the West, for example, how to negotiate,

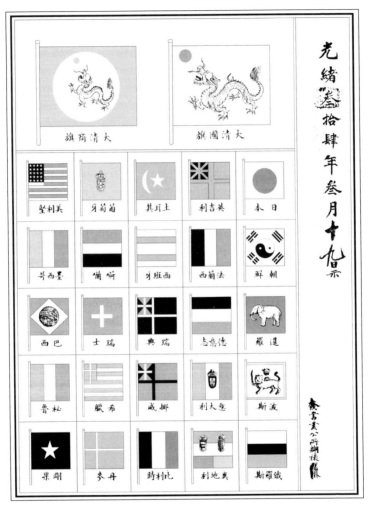

2.5. Illustrations of Chinese and foreign flags from an almanac for 1908. 20.5 cm. x 13.5 cm. On the top right is the Qing dynasty's national flag; on the top left, its commercial flag.

and avoid making mistakes in the foreign concessions, but also because the Chinese seem to have acquired a fondness for Western fashions in realms such as family life, food, medicine, and health care.

Immediately following its preliminary section on day-selection and the 'pursuit of good fortune', the *Guanshang bianlan* of 1905 gives pride of place to discussions of the Western calendar and its relationship to the new Chinese calendar. It then devotes a section to 'recent developments in China and the West', where the emphasis is clearly on the West. Among its 30 or so subsections are those pertaining to the history, size and population of various foreign countries; their products, capitals, governmental structures, military and naval forces, monetary systems, and political leaders; differences in time zones among the 'five continents'; equivalents for foreign and Chinese weights and measures, and so forth. Significantly, the *Guanshang bianlan* devotes an entire subsection to a listing of 'the special products' of Japan. Among the many fascinating illustrations in this and related sections of the book are the national flags of several dozen Asian and Western nations, as well as the portraits (and capsule biographies), of nearly 20 foreign Heads of State—from the emperors of Japan and Korea, to such Western dignitaries as England's Prince Edward, Russia's Czar Nicholas II, and the President of the United States, Theodore Roosevelt (Fig. 2.6).

The section on 'Sino-Western commercial affairs' is predictably large, and devotes considerable attention to Japan, despite its deceptively narrower title. Here we find information on the time schedules, prices and regulations of various transportation methods, including a number of Chinese train lines, the Russo-Chinese and Siberian railways, and steamships—both foreign and domestic. Similarly, the

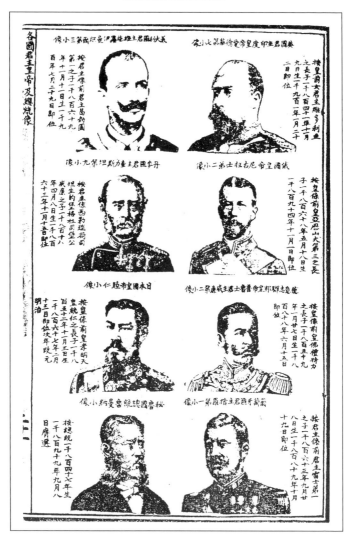

2.6. Portraits of foreign political leaders, including Prince Edward and Czar Nicholas (the first two individuals in the right-hand column). From an almanac for 1904. 20 cm. x 13 cm.

section on Sino-foreign postal administration includes information on rates, regulations, and insurance. Although most of the content of the *Guanshang bianlan* focuses on Chinese domestic concerns, including various elements of traditional culture, the section on 'miscellaneous arts' at the end of the book gives at least some attention to Western products and techniques, including food and medicines. We even find a palm-reading method based on a Western model!

3

Chinese Almanacs and Mainland Politics

ACCESS to new Western knowledge of all kinds, together with the relentless inroads of foreign imperialism, had revolutionary implications in the Middle Kingdom. As Chinese at all levels of society learned more about the West, (and about their own deteriorating political and economic situation), they became increasingly radicalized. Chinese nationalism, which had erupted explosively in the immediate aftermath of China's humiliating defeat in the Sino-Japanese War, continued to grow. In the period from 1901 to 1911, responding to the rising clamour for change that followed the Boxer Rebellion of 1900 and the demoralizing Allied occupation of Beijing, the Qing government initiated a series of political, military and educational reforms. These reforms, although designed to keep the Manchus in power, ultimately achieved the opposite effect. In 1911, a disorganized but popular and democratically-inspired revolution, led by Sun Yat-sen (Sun Zhongshan), succeeded in toppling the Qing dynasty.

Continuity and Change

The newly-established Republic of China, intent on distancing itself from the old regime, and anxious to promote a progressive image both at home and abroad, made no effort to legitimize itself with the hoary Mandate of Heaven idea. Nor did it attempt, in promulgating a 'new', Western-style Gregorian calendar, to preserve any traditional cosmological elements. The format of the Republic's first calendar for 1912,

a bland grey-green publication emanating from the 'Central Observatory' (*Zhongyang guanxiang tai*), offers a striking contrast to the last Qing calendar for the same year.

Local authorities in the provinces, following the lead of the central government, published their own local calendars, designed, like the Beijing prototype, to replace old-fashioned almanacs and to 'destroy superstition' (*po mixin*). But neither the feeble government in Beijing, nor local provincial officials, could eradicate centuries-old traditions by decree. As with Sino-Western almanacs produced by Christian missionaries in the early nineteenth century, and the calendars of the 1850s and 1860s promulgated by the Taipings, the new Republic's attempt to introduce a calendar devoid of lucky and unlucky days met with pronounced public resistance. Traditional-style almanacs continued to appear in huge quantities, as the writings of Daniel Kulp, Juliet Bredon and other contemporary observers in Republican China indicate.

Virtually all of the 100 or so almanacs I have seen dating from 1912 to 1949 contain the same basic cosmological and cultural material as their Qing counterparts. A number of these works self-consciously identify themselves with the imperial calendrical tradition, while others claim to belong to specific schools of Qing-style almanac-making—some relatively new, such as that of Cai Shoucai, of Guangdong province, and some of more ancient and illustrious pedigree, such as that of Hong Chaohe, whose descendants and disciples from Fujian perpetuated his pioneering models for over two centuries, down to the present. Although a few new activities appear as lucky or unlucky in the day-columns of Republican-era almanacs—notably kitchen-related undertakings, such as building a stove and sacrificing to the God of the Hearth—the overwhelming majority of the activities listed for any day of the year are the same as those

41

designated in the Qing statutes centuries before. Similarly, most of their morality tales are of the time-honoured sort: stories of Confucian cultural heroes, including the sage himself, and illustrated examples of the 24 paragons of filial piety.

Yet it would be a mistake to view Republican-period almanacs as merely carbon copies of their Qing dynasty precursors, for many contained cultural material that cannot be found in any previous almanacs, including those published in the transitional years between 1895 and 1911. Some, for example, introduced 'new' divination systems and a number included prophetic texts based on elaborate word play, such as Liu Bowen's 'Baked Pastry Song' (*Shaobing ge*), which offered political predictions of a sort that the Manchu rulers of Qing China considered threatening and utterly unacceptable. Almanacs published after 1911 also frequently provided information apparently designed to preserve historical memory at a time when China's imperial past and inherited values were under vigorous attack by iconoclastic intellectuals involved in the so-called New Culture Movement (c. 1915–27). Thus we find in some works, basic chronological lists of Chinese dynasties and their founding emperors, information which readers in Qing times would presumably have found completely unnecessary.

As with their late Qing counterparts, almanacs of the Republican era reveal the contours of change in Chinese society, as well as the bedrock of tradition. During the nearly four decades from 1911 to 1949, new knowledge came pouring into China, and interest in Western (and Japanese) things continued unabated. Some almanacs taught readers how to pronounce English words. Others introduced new ideas, such as the concept of time zones for the various parts of China. Maps of the world, at times wildly inaccurate, became more common. Meanwhile, almanacs continued to serve as a

means of transmitting information about changing domestic fashions, such as new styles of clothing and new marriage rituals (Fig. 3.1). The inclusion of this sort of information, explicitly designed to illustrate a degree of enlightenment or 'civilization' (*wenming*), recalls a similar effort in nineteenth century Japan—made significantly, by the early Meiji government itself.

One striking feature of almanacs in the Republican period is the periodic presence of modern-style advertising. Prior

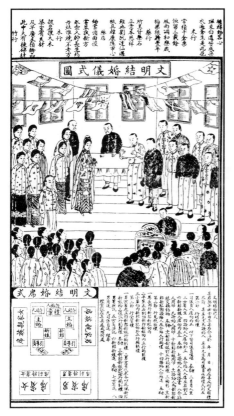

3.1. Depiction of a 'civilized' wedding ceremony from an almanac for 1917. 23 cm. x 13 cm.

to the 1911 revolution, a few publishers of almanacs included information on related works, such as books on divination, but nothing beyond their own limited inventory. Thereafter, however, particularly during the 1920s, we find a number of different products advertised in almanacs, from translations of Western writings to Chinese toys and paper products, from facial creams to cigarettes. The nationalism of the period is vividly portrayed in the advertising of one 1925 almanac—part of a set of 47 preserved in the East Asiatic Library of the University of California, Berkeley—which contains a large, illustrated advertisement for 'Patriot' cigarettes, the brand 'chosen by all patriotic [Chinese] gentlemen' (Fig. 3.2). Chinese nationalism also appears in the inscriptions on many almanac covers that read: 'Long Live the Republic'.

During the Republican era, almanacs and politics became closely intertwined. As had been the case in imperial times,

3.2. Advertisement for 'Patriot' cigarettes from an almanac for 1925. 15.5 cm. x 10.5 cm

almanac-makers attempted to associate themselves with the regime in power. Not surprisingly, we find that after 1911 the dates connected with almanacs are invariably designated as 'year so-and-so' of the Republic, although they are also still identified by the long-standing sexegenary system of stem-branch combinations. Almanacs that in the Qing period might bear the auspicious name of a hall or study, began to appropriate new names with explicitly political connotations. Thus, in a pattern characteristic of many other almanacs, the *Yingxue zhai fenlei guanshang bianlan* (Topical Guide for Officials and Merchants from the Study of Dazzling Snow) of 1905 became the *Zhonghua minguo bianlan* (Republic of China Reference) of 1915. A related device designed to make clear the connection between the almanac and the regime was the prominent display of China's national flag, either on the cover or on the inside of the book. A more subtle indication appeared in the illustrations that accompanied texts on coin divination, which depicted Western-style coins reading 'China's national currency', rather than the traditional square-holed, round coins of the imperial tradition.

Sadly for China, from 1916 to 1927 warlordism prevailed throughout the country. The parliamentary institutions established in 1912 proved too fragile to hold the centre, and Sun Yat-sen, first president of the Republic, had to relinquish his position as Head of State to a military man, Yuan Shikai. Yuan's death in 1916 precipitated more than a decade of fighting and political fragmentation. During this time, a number of almanacs carried pictures of well-known political and military leaders, presumably to indicate a measure of support for them. One such work, described as a 'combined lunar-solar almanac for the fifteenth year of the Republic of China [1926]', and apparently enjoying wide distribution, contains portraits of no less than 60 'great men' of the realm,

most still living at the time but a few deceased. Among the individuals represented are such famous (and occasionally infamous), political figures as Duan Qirui, Sun Yat-sen, Yuan Shikai, Li Yuanhong, Feng Guozhang, Xu Shichang, Zhang Zuolin, Cao Kun, Wu Peifu, Feng Yuxiang, Yan Xishan, and Liang Shiyi. Cai Yuanpei, a leading spirit of the New Culture Movement and one-time Chancellor of Beijing University, also appears (Fig. 3.3). Later editions pared down the number of the Republic's 'great men', but continued to publish portraits of them.

Nationalist Rule and 'National' Almanacs

After reunification of the country in 1927, the Nationalist (Guomindang) government in Nanjing tried to ban traditional-style almanacs as part of a systematic campaign to discourage 'superstition' as an 'obstacle to progress'. At the same time, they continued the practice of publishing an official, Western-style Gregorian calendar in the fashion of their Republican predecessors in Beijing. Between 1928 and 1930, seized by the spirit of 'progressive' reform, the Nationalists passed a series of laws designed not only to suppress 'old-style' almanacs, but also to abolish the traditional occupations of divination, including astrology, physiognomy, and geomancy. This effort failed miserably, however. Professional diviners of all sorts continued to ply their trade, and almanac-makers did not miss a beat. At the same time, many publishers of such works, anxious to demonstrate their loyalty to the new regime, began inserting the term 'national calendar' (*guoli*) before the term *tongshu* (almanac) as if to imply some sort of government sanction.

A combined lunar-solar almanac of 1928 helped establish the tone, displaying an eight-character couplet on the cover

3.3. Portraits of 'great men' from an almanac for 1926. 20.5 cm. x 13 cm. The top row of individuals includes (right to left): Duan Qirui, Sun Wen (Sun Yat-sen), Yuan Shikai, Li Yuanhong, and Feng Guozhang.

that read: 'Unity to China; Long Life to the Republic'. This new-style almanac provided illustrations and discussions of new clothing styles as well as examples of new civilized forms of marriage ritual. It also took pains to point out that the calendrical calculations on which the almanac was based were not like those of the old 'Perpetual calendar' (*Wannian li*) of imperial times. But in truth, the work reflected virtually all of the cosmological assumptions and divinatory information included in Qing-period almanacs.

Many *tongshu* for the year 1930 boasted a portrait of Sun Yat-sen on their front page, together with his famous 'will', signed shortly before his death on March 12, 1925 (Fig. 3.4). This brief but powerful document encouraged Sun's followers to carry on the revolutionary struggle for freedom and equality in China that he had been waging for the last 40 years. Clearly the incentive for including this material was an effort on the part of publishers to seek official approval for their almanacs in the wake of government prohibitions against 'old-style' *tongshu* issued during the previous year.

But not all publishers responded in exactly the same way to the new circumstances. Some took an explicitly political tack, discussing the background of the 'new calendar' of the Nationalists, printing documents related to it, promoting Sun's political ideas, and commemorating a large number of 'revolutionary anniversaries'. The compromise struck in almanacs of this sort was to include some features of the old cosmology (such as Nine Palace charts and the designation of various lucky and unlucky activities in day-columns), but to omit depictions or discussions of certain other features of traditional-style *tongshu* (such as the spring ox and Earth Mother Classic). Other almanac-makers, a majority it appears, simply paid lip-service to the Nationalists and continued to publish standard models

3.4. Sun Yat-sen's officially-sanctioned portrait and 'will' on the cover of an almanac for 1930. 20 cm. x 13 cm.

throughout the 1930s and 1940s. In the words of V. R. Burkhardt, writing in the early 1950s: 'Although the Republic with its new broom introduced the Western calendar', the Nationalists by no means 'succeeded in weaning people from their hardy annual, with its predictions for the harvest, fortune-telling, talismans and lucky days for the normal activities of life'.

To my knowledge, the only large-scale and sustained effort to revive a State-sponsored traditional Chinese cosmology occurred when the Japanese established the puppet State of 'Manchukuo' in 1931, and installed the last Qing emperor, Puyi, as its titular ruler. At that time, they published a State calendar (entitled *Shixian shu*) that virtually replicated the old Qing dynasty model, in hopes of once again putting the inherited cosmology to work in the service of the State. Extant copies of this calendar in the Library of Congress reveal not only a concerted attempt to legitimize both the conquest and the calendar by reference to the late Qing emperor, but also an attempt to popularize it in the fashion of almanacs by including, in some versions, at least, depictions of the spring ox and herdsman (Fig. 3.5). Although the calendar was confined only to Manchuria, and did not outlast the Japanese conquest, it suggests that in the mind of the Japanese, the association between the imperial institution and the traditional cosmology was still strong enough to exploit.

Almanacs in the Early People's Republic

For a few years after the establishment of the People's Republic of China (PRC) in 1949, private publishers continued to print old-style almanacs on the Mainland, as they did also in the British colony of Hong Kong and the Republic of China

太歲在己卯　幹土枝木　納音屬土　歲德在甲合在己

陽貴人在子歲　祿在午
陰貴人在申歲　馬在巳

凡例

一、本時憲書以太陽曆為主附
　　註太陰曆以資參考
一、凡時刻以我國標準時即東
　　經一百三十五度之平時
一、日出入時刻以日面上邊見
　　於地平線上之時刻為準
一、月出入時刻以月面中心見
　　於地平線上之時刻為準
一、日出（入）方位即日出（入）
　　時自正東（西）起算而向南
　　北所測之日面中心方位角
一、每月節氣下所載日出入時
　　刻以新京為準
一、卷末附載關於氣象農事之
　　表及其他諸重要事項以供
　　日用參考

康德六年

三

春牛芒神式

春牛身高四尺頭至尾椿長八尺
頭黃色身青色腹黃色角耳尾
黑色膝脛白色蹄白色尾長一
尺二寸右繳口合籠頭拘繩用
黃色苧繩踏板用縣門右扇用
牡像紅衣黑腰帶平梳兩髻在
耳前罨耳全戴行纏鞋袴俱全
左行纏懸於腰鞭杖用柳枝長
二尺四寸鞭結用苧五色醮染
芒神早忙立於牛右前邊

嫁娶周堂圖

年神方位之圖

社	末伏	中伏	初伏
陽九月二十八日	陽三月二十二日	陽八月十一日	陽七月二十二日　陽七月十二日
陰八月十六日	陰二月初二日	陰六月廿六日	陰六月初六日　陰五月廿六日

3.5. The 'Official' Calendar of 'Manchukuo' for 1939 (year 6 of the Kangde reign). 17.5 cm. x 12 cm. The introductory remarks indicate that the calendar is based on a solar model, but the text itself includes a Qing-style 'Diagram of the Position of the Spirits for the Year', a description of the spring ox and herdsman, and a *zhoutang* for marriage 'day-selection'. The day-columns on subsequent pages indicate lucky and unlucky days for various activities in the fashion of Qing calendars and almanacs.

51

(ROC) on Taiwan (see Chapter 4). But the highly-charged revolutionary climate of the Mainland, exacerbated by the PRC's involvement in the Korean War, made publication of traditional almanacs hazardous. Under these circumstances, some publishers tried to strike a balance between inherited concerns and modern Chinese politics. One Mainland edition, for instance, published in 1953, contained the usual cosmological and astrological information, but also bore the title of the new regime and displayed political slogans such as 'Oppose America and Assist Korea' (*kang Mei yuan Chao*).

Meanwhile, the Chinese Communist Party (CCP) published its own 'new almanacs' (*xin tongshu*) as part of a systematic campaign to discredit old-fashioned 'superstitions' nationwide. This effort was the logical extension of earlier but more limited attempts to transform the traditional world view of the Chinese peasants in newly 'liberated' areas of China, both in the south during the late 1920s and early 1930s, and in the north from 1935 onward. Even prior to their successful conquest of the Mainland in 1949, the Chinese Communists had already begun publishing small farmers' almanacs (*nongcun lishu*) in north China, designed not only to convey basic agricultural information to the rural masses but also to propagandize on behalf of the Party.

After national 'liberation', the CCP continued to seek the eradication of popular beliefs by means of 'new almanacs'. Sometimes the effort had a regional focus. In 1951, for example, a branch office of the People's Publishing House, representing the Guangdong provincial government, produced a work for the upcoming year called the *Hua'nan tongshu* (South China Almanac). This work—targeted specifically at a regional audience long known for its 'superstitious beliefs', and apparently distributed at no cost to the Guangdong peasantry—amply illustrates the State's political priorities

52

and its approach to the transformation of Chinese rural society. The multi-coloured cover depicts an obviously contented man and woman holding, respectively, a sheaf of grain and three bolts of new cloth. In the background are two sets of lanterns, one with the inscription 'Love of Country' and the other with the words 'Flourishing Production'. Off to one side, a large container is filled with grain. In the foreground a group of three children play, surrounded by all sorts of fruits and vegetables. On the inside cover is a large photograph of Mao Zedong, 'Chairman of the Central People's Government of the People's Republic of China'.

The contents of this almanac are revealing. It is divided into four main sections: one on politics and society; one on calendrical matters; one on agricultural production; and one on hygiene. In the first section, we find information on the new administrative divisions of China, including several national maps and one regional one. Next is an illustrated discussion entitled 'Loving Our Great Motherland,' which discusses China's size, population, ethnic composition, products, and cultural achievements, emphasizing the PRC's uniqueness and superiority over other nations of the world. Another subsection, also illustrated and entitled 'Thirty Years of the Chinese Communist Party's Glorious Struggle', highlights the history of foreign imperialism in China, the introduction of Marxism-Leninism, and, of course, the accomplishments of the Party under Chairman Mao's leadership.

More illustrated propaganda follows, stressing: the alliance between the PRC and the Soviet Union; the new 'democracy' on the Mainland; the persistent threat of foreign imperialism; and the peace, prosperity and security provided to the Chinese people by the new CCP government. There is also a long

discussion of national holidays, followed by two pages of models for 'New Spring Couplets'. The vast majority of these paired verses, 42 in all, focus on recurrent themes of revolutionary commitment, hard work, unity, co-operative labour, social harmony, education, productivity, anti-imperialism, and so forth. At least a few implicitly assail traditional beliefs, such as geomancy. One 16-character couplet reads, 'Dig wells and open channels without fear of calamities. Deep plowing and careful work will yield a bountiful harvest'. The section on politics ends with two major entries devoted to recent legislation (regulations respecting counter-revolutionary activity, and the full text of China's new marriage law); and a series of brief biographical sketches of local revolutionaries entitled 'Heroic [Role] Models of South China'.

The next section of the *Hua'nan tongshu*, on calendrical affairs, begins with a picture of the 'spring ox' for 1952; but there is no hint of the traditional agricultural symbolism that once surrounded it. Rather, a plain peasant woman leads the ox, and a brief text of eight lines touts the 'convenient' change from a lunar to a solar calendar. The almanac also provides a standard chart of the 24 solar divisions for the year, and a list correlating the 12 birth animals with the age of people in 1952. Significantly, there are no traditional indications of marital compatibility; only fascinating explanations of the Gregorian calendar and the 'worldwide' system of dating based on the birth of Jesus, 'founder of Christianity'. This section concludes with an illustrated discussion of the effect of the moon on tides.

The section on agriculture emphasizes techniques of managing fields and orchards for maximum output. It contains illustrated introductions to various new techniques and technologies, as well as concrete advice on how to protect

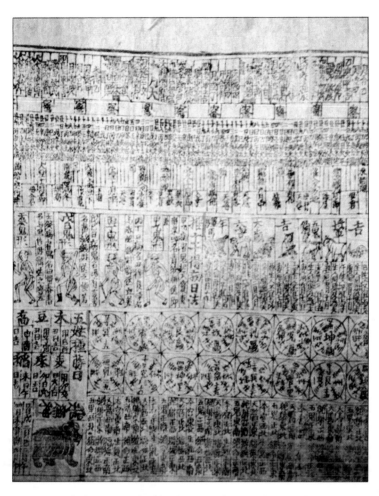

1. Portion of a late Tang almanac from Dunhuang, showing day columns, zodiacal animals and various fate extrapolation systems. Courtesy of the British Library (public exhibition). 17 cm. x 12 cm.

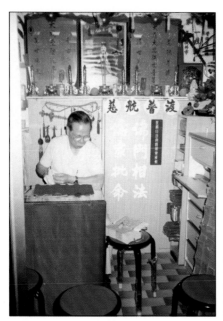

2. A Hong Kong fortune-teller with his almanac (resting on a stool to his left). Photograph by the author.

3. 'Important Affairs of the Year' from an almanac for 1991. 18 cm. x 10.3 cm.

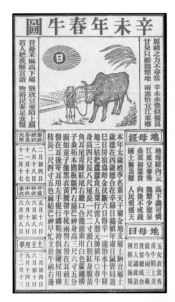

4. The spring ox and herdsman, from an almanac for 1819. 16.5 cm. x 11 cm.

5. The use of divining blocks at a small temple in contemporary Xiamen (Amoy), Fujian province, the People's Republic of China. Photograph by the author.

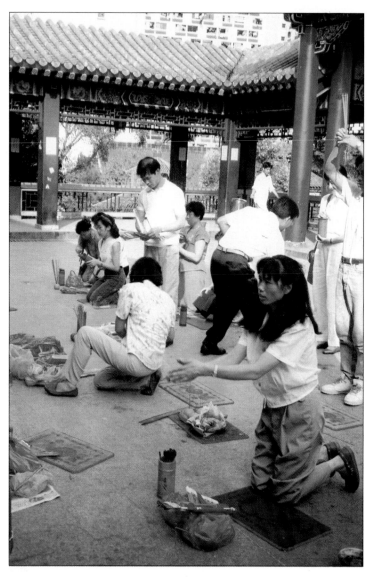

6. The use of spiritual sticks in contemporary Hong Kong at the Wang Daxian (Wong Tai Sin) Temple. Photograph by the author.

7. A fortune-teller's table in contemporary Hong Kong. A photocopy of the 'Heavenly Official' chart is situated directly below his almanac. To the left is a chart of birth years and zodiacal animals, also copied from an almanac. Photograph by the author. See also Fig. 2.3.

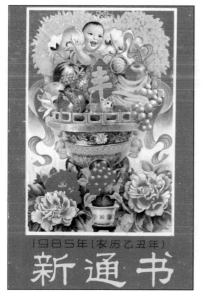

8. Cover of a 'new almanac' for 1985. 18.5 cm. x 12 cm.

9. Cover of a Hong Kong almanac for 1988. 25 cm. x 12.5 cm.

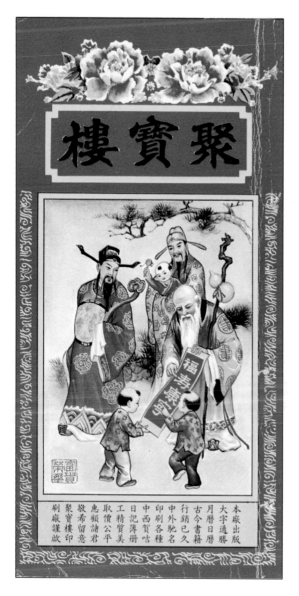

10. Cover of a Hong Kong almanac for 1990. 25 cm. x 13 cm.

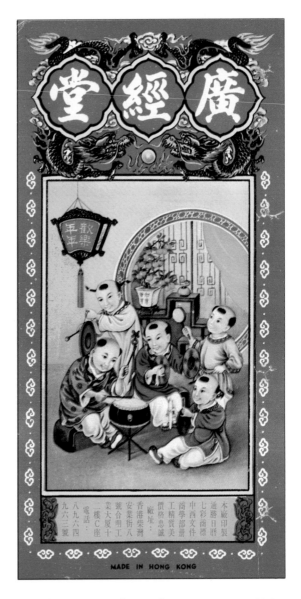

11. Cover of a Hong Kong almanac for 1991. 24.5 cm. x 12.5 cm.

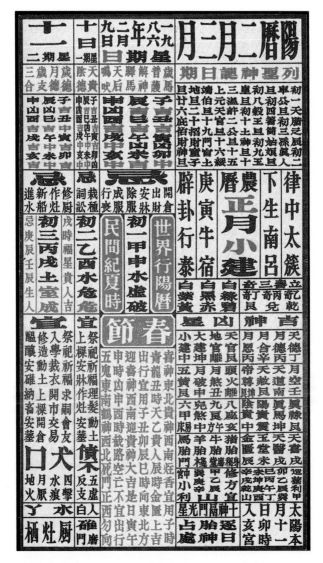

12. Day columns from a Hong Kong almanac for 1986. 18 cm. x 10 cm. The text covers the first three days of the lunar new year, which correspond to February 9–11, 1986 in the Western calendar.

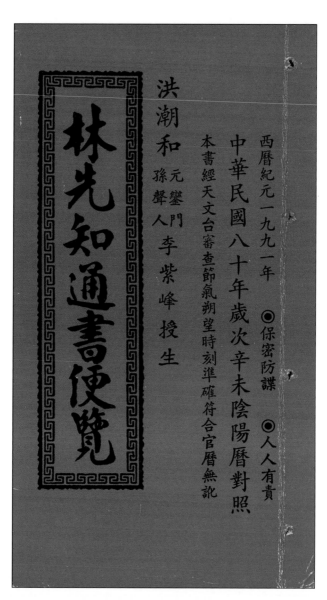

林先知通書便覽

洪潮和

元鑑門　孫聲人　李紫峰　授生

西曆紀元一九九一年　◉保密防諜　◉人人有責

中華民國八十年歲次辛未陰陽曆對照

本書經天文台審查節氣朔望時刻準確符合官曆無訛

13. The cover of Lin Xianzhi's almanac for 1991. 19 cm. x 10.5 cm.

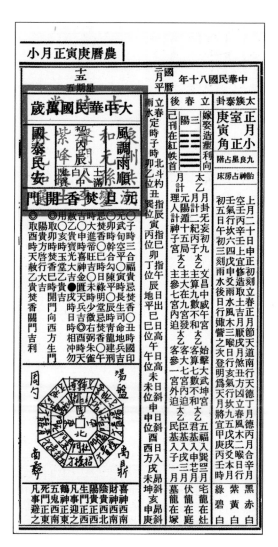

14. The initial page of Lin Xianzhi's section on day-columns for the lunar new year (1991; see Plate 13). 18 cm. x 9 cm. The red seal, which, like the cover, explicitly links Lin's almanac to the hoary tradition of Hong Chaohe, is placed strategically to accentuate a horizontal inscription that reads: 'Long Live the Great Republic of China'.

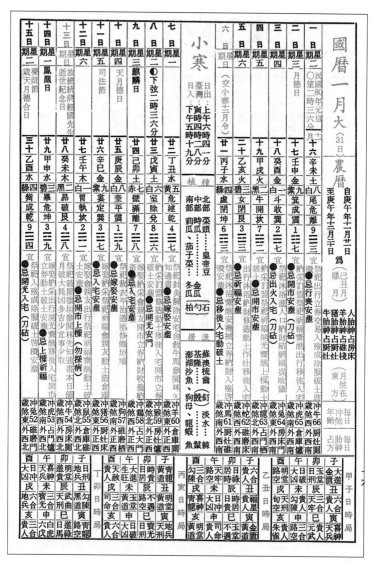

15. Day-columns from a 'people's almanac' for 1991 (Taiwan). 18 cm. x 12.5 cm. Note the use of *Yijing* symbolism (trigrams), which can also be found in the day-column sections of various *tongshu bianlan*.

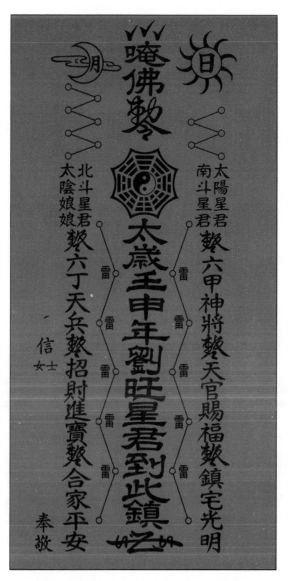

16. A 'Great Year Star' charm contained in a 'people's almanac' for 1991 (Taiwan). 23 cm. x 13 cm.

中華民國七十五年　歲次丙寅年

我國民曆

內容最豐富
內附太歲符

今年出生者肖虎

恭喜發財

17. The cover of a 'people's almanac' from Taiwan for 1986, indicating that it is the year of the tiger. 20.5 cm. x 14 cm. The primary symbolism of this cover is Buddhist, but there are also Daoist elements, such as the cranes, symbolizing longevity.

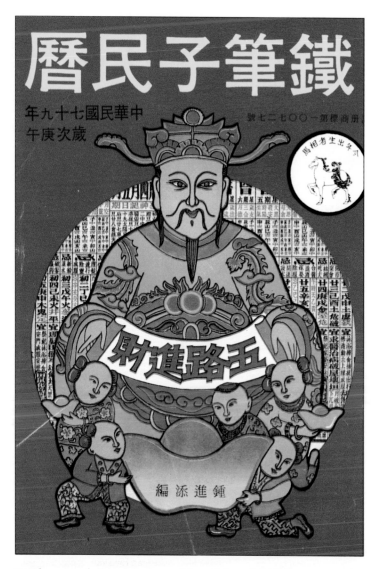

18. The cover of a 'people's almanac' from Taiwan (1990). Here, against the background of day-columns, the message for the New Year is 'Wealth from All Directions'. 20.5 cm. x 14.5 cm.

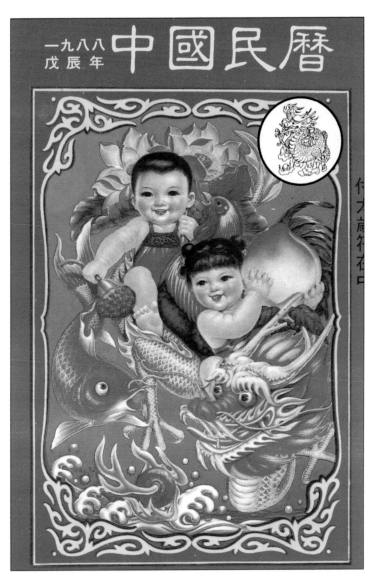

19. A Taiwan-style 'people's almanac' for 1988, also published and distributed in Hong Kong. 20.5 cm. x 14 cm.

crops from pests. In the same spirit, and through the use of similar imagery, the section on hygiene shows the many ways by which raw sewage, spitting, coughing, rats and flies can transmit disease. It discusses common afflictions, such as colds, and what to do about them. The *Hua'nan tongshu* also gives attention to matters such as menstruation, pregnancy, childbirth and postnatal care. Although no specific information appears concerning sexual intercourse, the almanac offers counsel to pregnant mothers regarding eating and drinking habits, clothing, sleep, and so forth. It also indicates the importance of seeking medical assistance for delivery, if at all possible. The almanac concludes with instructions for dealing with emergencies such as drowning, serious bleeding, broken bones, heat prostration and the like, as well as a discussion of common internal and external medicines.

Other 'new almanacs' published by the PRC after 1950 but aimed at a national audience, addressed the same basic concerns, although their content naturally changed some-what, according to shifts in the party line. Not surprisingly, during the tumultuous Cultural Revolution (1966–76)—a period of vigorous and sustained criticism of both foreign 'bourgeois' influences and indigenous 'feudal' practices— State-sponsored almanacs assailed traditional beliefs with a vengeance. One such work, for the year 1966, contained, in addition to the usual practical information and propaganda, a two-page section entitled 'Stress Science and Destroy Superstition'. In it, deities such as the 'King of Hell' and the 'Stove God' received blistering criticism as deceptive creations of the 'feudal reactionary class' (Fig. 3.6). Similarly, the almanac castigated geomancy as a counter-revolutionary tool, utterly unworthy of belief. Mocking the esoteric language of traditional *fengshui* specialists, the editors cited

讲科学 破迷信

地下没有"阎王"

封建反动阶级说，地下有一个"阴曹地府"，有"十八层地狱"，有"阎罗王"，敢于起来反抗他们压迫和剥削的人，死后就要受"阎罗王"审判受罪。这完全是胡说八道。

科学告诉我们，地球是个实心的东西，地球的内部大体分为三层，最上面的一层，叫做地壳，里面差不多都是岩石，岩石里面埋藏着金、银、铜、铁、锡、煤炭、石油等一百多种矿物；地壳下面是中间层，在中间层里，也都是一些矿物，有的已经熔化成岩浆；中间层下面是地心，也叫地核，地核里温度极高，除了岩浆以外，什么东西都不存在。所以，不论在地壳、中间层和地核里，都根本没有"阴曹地府"和"地狱"，哪里会有什么"阎罗王"呢？

"阎罗王"的传说，完全是剥削阶级捏造出来吓唬人的。他们编了一套"因果报应"的鬼话，并把那些屠杀过人民的、血债累累的、已经死去的官封为"阎罗王"，说什么反抗他们统治的人，死后都要被"阎罗王"惩罚，目的无非是要人们死心塌地地受他们的压迫和剥削。所以说，所谓"阎罗王"，完全是剥削阶级用来恫吓人民、欺骗人民的一种工具，实际上是不存在的，我们千万别上当。

"灶君上天"完全是瞎说

3.6. 'Stress Science and Destroy Superstition', from a 'new almanac' for 1966. 17.5 cm. x 12 cm.

a sarcastic ditty drawn from the Qing dynasty: 'Geomancers are accustomed to talking nonsense, pointing north, south, east and west. If mountains have sites that will produce noble rank [in the future], why don't they bury their own fathers in these places?'

Other forms of divination, from physiognomy and word analysis to various systems of coin-tossing and fate extrapolation, also fell under heavy attack in this work. The assault, not nearly as detailed as the critique of *fengshui*, centred on the idea that fortune-tellers were nothing more than unscrupulous frauds; devious, manipulative people who played on the fears and anxieties of others. The *xin tongshu* did, however, devote considerable space to refuting

56

the idea of fate based on one's 'eight characters'. Taking an obvious and well-worn path of attack, the almanac derisively questioned whether all of the people born in the world at the same time could possibly have the same destiny.

Almanacs of the 1980s

Following the death of Mao Zedong in 1976, and the inauguration of the so-called 'Open Policy' of Deng Xiaoping in 1978, China began to change rapidly and dramatically. A new emphasis on pragmatic administration, an unprecedented receptiveness to foreign influences, and a certain 'liberalization' in Chinese intellectual and cultural life, helped pave the way. The normalization of China's relations with the United States in 1979, and the aggressive pursuit of Western assistance in a concerted drive to achieve the 'Four Modernizations' (agriculture, industry, science and technology, and national defence), opened China's doors ever wider. At the same time, the State tried to promote a modified version of Marxist-Leninist ideology and continued to act as the self-conscious guardian of China's 'socialist spiritual civilization', hoping to strike a congenial and effective balance between rapid economic growth and social and political stability.

In many respects, State-sponsored almanacs of the 1980s are similar to the *xin tongshu* of earlier periods. Their covers, for example, convey the same sort of optimistic symbolism—fruits and flowers, fully ripened grain, happy children and auspicious animals (plate 8). As usual, they contain up-to-date practical knowledge regarding agricultural production, health and hygiene, science, mathematics, and technology. They also continue to promote official orthodoxy by means of slogans. Some state simple and obvious truths, such as 'Children are the future of the motherland'. Others, by far

the majority, refer to contemporary political campaigns designed to promote patriotism, socialist ethics, 'spiritual civilization', the Four Modernizations, and so on. A typical paired phrase reads: 'The Party has a policy of enriching the people; the people have the motivation to love the country'. Even couplets designed for wedding decorations could sometimes carry political messages: 'Renew the man, renew the woman, renew the prevailing practices; love the party, love the country, love the (Chinese) people'.

But official almanacs of the 1980s also reflect a more tolerant intellectual climate than in most earlier periods of the PRC. Although still bereft of divinatory elements, these works evince the State's willingness to promote at least some traditional forms of cultural knowledge. Among their numerous slogans and couplets are a few folk aphorisms, as well as several old-style paired phrases conveying conventional images of springtime and time-worn themes of longevity and prosperity. Some 'new almanacs' also include simple, straightforward historical discussions of China's dynastic past, along with information on ancient capitals from the Shang dynasty up to the Qing. A few even provide examples of traditional stories designed explicitly for use in 'family education'. These tales involve well-known cultural heroes such as Zengcan (a disciple of Confucius), the mother of Mencius, Zhuge Liang and Sima Guang. One almanac even contains a short account of Zhu Bolu's 'Family Instructions', dating from the seventeenth century (see Chapter 4; Fig. 4.2).

Personal family matters receive far more attention in almanacs of the 1980s than those of the 1950s, 1960s and 1970s in the PRC. We find, for example, detailed discussions concerning the management of household finances, the proper care of both young children and aged family

members, useful cooking tips, domestic education, and even the particular problems involved in raising only-children. A *xin tongshu* published in Guangdong for the year 1985 not only acknowledged a deep-seated and long-standing preference for males in Chinese society ('looking forward to the child becoming a dragon', in the traditional cliché cited by the editors), but also offered 14 specific 'don'ts' in the raising of only-children, all aimed toward preventing them from becoming lazy, selfish, impolite and irresponsible.

One of the most striking features of contemporary almanacs is the degree to which they testify to China's new, free-wheeling economic environment in the countryside. In contrast to the earlier co-operative or collective emphasis in most officially published *xin tongshu*, works of the 1980s seem designed to assist entrepreneurs in maximizing the opportunities for individual gain occasioned by innovations such as the 'production responsibility system' and the opening of 'free markets'. Thus we not only find tips on how to manage the 'family economy', but also advice on how to get more eggs from a hen, or how to raise fish and ducks simultaneously for greater profit.

On the whole, the emphasis in 'new almanacs' of the 1980s remains on practical matters. But some contemporary *xin tongshu* contain items of no apparent practical value and no obvious political purpose, for example, amusing anecdotes, puzzles, and magic tricks. In this limited respect, and in contrast to most other Chinese almanacs, past or present, they resemble Western almanacs of the nineteenth and twentieth centuries. Furthermore, one can now find essays on such relatively esoteric topics as the origin of Chinese surnames, and the background of the dragon as a Chinese cultural symbol. There are even answers to simple questions

based purely on curiosity, such as 'How high is the sky?' or 'How thick is the earth?'

What one still cannot discover in official *tongshu*, however, is what the future holds. For this reason, privately printed fortune-telling manuals and old-style almanacs have begun to appear on the Mainland in recent years. Some such works are produced in Hong Kong. In 1989 for example, peddlers offered for sale on the streets of Beijing a thin, pink-coloured volume entitled *Xiantian bagua tu* (Illustrations of the Former Heaven Sequence of the Eight Trigrams), published by the Hong Kong Buddhist Association in conjunction with a Japanese cultural research institute. Like almanacs of both the Qing period and the early Republic, this work contains a rough approximation of a *liunian* chart, information on both the nature and marital compatibility of people born in years marked by one or another of the 12 zodiacal animals, and details on a number of divination systems, including physiognomy (Fig. 3.7). It even has a section on dream interpretation, attributed, like several other mantic systems in the book, to the legendary Zhuge Liang of the Three Kingdoms period. It lacks, however, day-columns, and is thus not really an almanac in the traditional sense.

Another work, published privately in Changsha, Hunan, and entitled *Gongyuan yijiu baba nian wuchen lishu* (Almanac for AD 1988), has a *liunian* chart, a picture of the spring ox and herdsman (but no descriptive texts) and day-columns, but not much else (Fig. 3.8). Consisting of only 16 crudely-printed pages, it supplies very little practical, historical, or cultural information, either traditional or modern. It does, however, contain a few old-style couplets for auspicious occasions, a chart of family names, and a list of important dates, including the National Youth Festival (commemorating the May 4 Incident of 1919), the founding

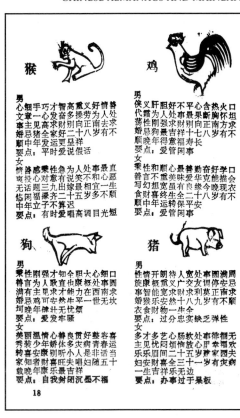

3.7. Some zodiacal animals from the *Xiantian bagua tu* (Hong Kong, 1989). 15.5 cm. x 10.5 cm. The text breaks down the characteristics of each animal into 'male' and 'female' categories.

of the Chinese Communist Party (1921), and the anniversary dates for the deaths of several Marxist luminaries, from Mao Zedong, Zhu De, Zhou Enlai and Liu Shaoqi to Lenin and Stalin (but not Marx).

It is difficult to gauge the popularity of traditional-style almanacs in the People's Republic of China today, because of the State's unremitting hostility towards them. But anecdotal evidence suggests that they would be far more prevalent if the government were even slightly less intolerant.

二月小　乙卯　杨公忌　十一　　披麻　初二

星期	5	4	3	2	1	日	6	5	4	3	2	1	日	6	5
阳历	4月	31	30	29	28	27	26	25	24	23	22	21	20	19	18
农历	十五	十四	十三	十二	十一	初十	初九	初八	初七	初六	初五	初四	初三	初二	初一
干支	丙戌土	乙酉水	甲申水	癸未木	壬午木	辛巳金	庚辰金	己卯土	戊寅土	丁丑水	丙子水	乙亥火	甲戌火	癸酉金	壬申金
建除	危牛	破斗	执箕	定尾	平心	满房	除氐	建亢	闭角	开轸	收翼	成张	危星	破柳	执鬼
宜忌	取鱼嫁娶	无取	修造动土卜	百事昌	平沿遣涂斩草	宜祭祀福	赴任出行	无取	合帐（春社）	笠柱上梁安门	嫁娶裁种	修造动土	大吉酉时春分	无取四离日	宜取鱼驾马

星期	5	4	3	2	1	日	6	5	4	3	2	1	日	6
阳历	15	14	13	12	11	10	9	8	7	6	5	4	3	2
农历	廿九	廿八	廿七	廿六	廿五	廿四	廿三	廿二	廿十	十九	十九	十八	十七	十六
干支	庚子土	己亥木	戊戌木	丁酉火	丙申火	乙未金	甲午金	癸巳水	壬辰水	辛卯木	庚寅木	己丑火	戊子火	丁亥土
建除	成鬼	危井	破参	执觜	定毕	平昴	满胃	除娄	建奎	闭壁	开室	收危	危虚	成女
宜忌	百事大吉	休俗安床捕捉	求医治病	起工驾马	百事昌	无取	宜裁衣开市除服	冠笄安床笠柱上梁	安床合帐盖屋	出行安床作灶安葬	宜进人口捕捉除服	亥时清明	百事昌	

3.8. Day-columns of a privately printed almanac. 15.5 cm. x 10.5 cm.

This much we know. The inherited cosmology is far from dead in the minds of many Chinese on the Mainland. Fortune-tellers can be found throughout the PRC, not only in the countryside, but also in major cities, and traditional-style almanacs brought into China from Hong Kong and Taiwan are always in demand, at least in southern areas of the country.

4

Almanacs in Present-day Hong Kong and Taiwan

ALTHOUGH the private publication of traditional-style almanacs on the Mainland remains an extremely minor enterprise, it is big business on Taiwan and in Hong Kong. Since 1949, both non-communist Chinese environments have modernized successfully, but in neither case has the process fundamentally undermined Chinese tradition. Rather, Hong Kong and Taiwan highlight what appears to be the fallacy of Maoist thinking—that in order to achieve rapid economic growth, 'superstitious' practices such as divination and popular religion have to be abandoned. Of course, it is true that the Chinese Communist approach to revolution involved much more than simply enhancing productivity; it aimed at a thorough social and political transformation as well. Considering these goals, and in light of the sheer magnitude of the physical and demographic challenges facing Mao and his associates, an effort to attack the cultural foundations of 'feudal' authority in China was perhaps not entirely unreasonable. But now that the PRC has openly acknowledged the limitations of Marxist-Leninist ideology, and has opted for a developmental model that includes elements of a market economy and limited 'private' enterprise, perhaps the experience of Taiwan and Hong Kong will point the way to a new cultural strategy on the Mainland.

Hong Kong Almanacs

Hong Kong is, of course, a special case, having been a British territory from 1842 onward. As a result, the cataclysmic political changes that occurred on the Mainland during the late nineteenth century and the first half of the twentieth, had comparatively little cultural effect on the colony. This is not to say that conflicts never arose, but on the whole, British colonial administration was not directed toward the transformation of Chinese religious beliefs and popular customs. For this reason, among others, almanacs have remained extremely popular in Hong Kong to this day.

Hong Kong almanacs are generally called *tongsheng,* rather than *tongshu,* since to Cantonese speakers the character *shu* (book) is too close in sound to another character (輸), also pronounced *shu,* which can mean 'to lose', as in gambling. *Sheng,* on the other hand, means 'victory', and thus carries far more positive connotations. The striking feature of *tongsheng* is their obvious continuity with Qing dynasty models. Virtually every traditional category of concern in the almanacs of late imperial times can be found in contemporary almanacs from Hong Kong, but because of the colony's unique status as a British territory, Western ideas have found their way into local *tongsheng* with particular speed and ease. More incentive has always existed for enterprising Chinese to learn about the West in Hong Kong than in other parts of China, and thus the almanacs produced in the territory have long been especially receptive to foreign information.

Naturally enough, the bilingual environment of Hong Kong encouraged many Chinese to learn at least some English. The basic approach used by almanac-makers, which continues into the present, was to provide a list of commonly

used foreign words, terms and phrases, together with their literal meaning in Chinese, as well as the character or combination of characters that most closely approximated the foreign sound. But the distinctiveness of the Cantonese dialect, so different in pronunciation from most of the major dialects found in other parts of China, limited the appeal of words transliterated in *tongsheng* almost exclusively to Cantonese-speaking regions of Guangdong province. For instance, the characters used to render the English phrase 'no cash' (奴加示), when pronounced in Cantonese ('no kah shee'), are reasonably faithful to the sound of the English original, but in the Mandarin dialect, the phrase becomes something like 'new jeeya shur'—utterly unrecognizable as an equivalent pronunciation.

Several other features of Hong Kong almanacs merit our attention. One is their attractive covers. Rich in both colour and symbolism, they invariably reflect cherished elements of traditional Chinese culture: calligraphic inscriptions; old-style clothing; time-honoured themes (family life, children playing, celebrations connected with the new year); and symbols suggestive of blessings and long life (plates 9, 10 and 11).

Another distinctive feature of *tongsheng* is their relatively uniform content. It is true that they have different cover designs, and are of different thicknesses and that some contain advertising while others do not. But the core materials are invariably the same. One reason for this, aside from the obvious inertia of tradition, is the authority enjoyed by certain divinatory specialists in Hong Kong. At present, a man named Cai Boli, a descendant of Cai Shoucai, exerts the most profound influence. His calculations for day-columns are considered authoritative, and they provide the foundation for all major *tongsheng* in the territory. Thus, even though

almanacs are produced by different publishing houses and temple associations, they display a remarkable agreement regarding lucky and unlucky activities for any given day, in any particular year (plate 12). I have not been able to discover, however, exactly how his materials find their way to various printers.

Among the more 'practical' elements likely to be added to the basic day-columns, charts and diagrams of any Hong Kong almanac is advice on agricultural affairs such as ploughing and planting, information on writing, ritual and etiquette, and tables of useful phrases in English. A number of *tongsheng* include charts showing the numerical equivalents for characters to be used in telegraphic messages, and scientific explanations of natural phenomena, such as eclipses. They also have modern star maps, and discussions on the difference between lunar and solar calendars. Some supply information on the conduct of business, and at least a few provide lists of simplified characters currently in use on the Chinese Mainland.

Most *tongsheng* provide a great deal of self-consciously 'cultural' material, such as a listing of the several hundred Chinese family names and their particular place of origin. Each page of this listing also includes illustrations of a few famous individuals in Chinese history who bore these names—Confucius and several of his disciples, the warrior Guan Yu of the Three Kingdoms period, Zhao Kuangyin, founder of the Song dynasty, and so on (Fig. 4.1). The only woman to be singled out is Confucius' mother. Inclusion of this material in the almanac testifies to the enduring importance of the family and one's home area in Chinese social life.

Hong Kong almanacs usually feature didactic material of one kind or another, including the 'Twenty-Four Paragons of

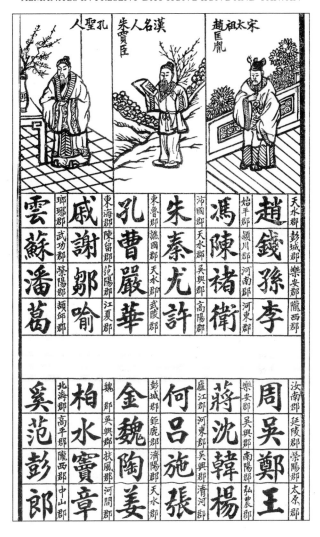

4.1. A list of 'Family Names' from a Hong Kong almanac for 1986. 18 cm. x 10.5 cm. The notables depicted here include (right to left), Zhao Kuangyin, Zhu Maichen (a Han dynasty scholar), and Confucius himself.

Filial Piety'. An especially common feature of amplified *tongsheng* is an annotated version of 'The Family Regulations of Master Zhu [Bolu]' (Fig. 4.2). This famous seventeenth-century work consists of 30 basic precepts having to do with

4.2. The first section of Zhu Bolu's 'Family Regulations', on sweeping the house clean. From a Hong Kong almanac for 1986. 18 cm. x 10.5 cm.

proper behaviour. It advises readers, assumed to be adult males, to be tidy, live frugally, and not covet the possessions of others. The head of the household, we are told, should be kind, considerate, and generous. Children in the family should read the Confucian classics and be taught justice and fairness. All members of the family must keep proper company and avoid lawsuits, 'for litigation will bring misfortune in the end'. The clear thrust of this tract is on the maintenance of family harmony, the preservation of status distinctions and social order, and the subordination of family interests to those of the State. The 'Family Instructions' conclude by applauding the person who 'fulfills his duties, rests content with fate, follows the dictates of time and circumstance, and listens to [the commands of] Heaven'.

A similar section offers 'sage' advice to readers. The basic point here, we discover, is to 'know oneself and to know others'. Focused on about a dozen illustrated parables or metaphors, this section contains common-sense observations on how to evaluate character and improve behaviour. The text often reads like a string of folk aphorisms, many of which ring familiar to all Chinese: 'Think three times before acting'; 'To rely on others is not as good as relying on yourself'; 'Life and death are matters of fate'; 'Wealth and high position come from Heaven'; 'Good will be requited by good, and evil by evil'; 'A rich person thinks of the coming year, while the poor person thinks [only] of the present'. Often information appears in the form of analogies drawn from nature. Thus, we learn that some people are like crabs, shifty and indirect. At times, however, the metaphorical connections between human beings and nature are not intuitively obvious. For example, 'If a stream is too clear, it will have no fish, and if a man is too anxious he will not have wisdom'.

Many amplified *tongsheng* contain a fascinating little folk tale entitled simply 'The Child'. It revolves around a verbal exchange between Confucius and a small boy whom the sage meets in the course of his travels with a few disciples. The boy, obviously intelligent and quick-witted, answers a series of questions posed by Confucius, and in so doing makes a number of points about proper behaviour. When the sage mentions that he would like to make the boy his travelling companion, the prodigy takes the opportunity to lecture Confucius on the importance of family obligations and loyalty to one's teachers. A question about gambling invites a denunciation of such idle play, and another query on governing leads the child to hold forth on the need to preserve status distinctions in Chinese society. Throughout the tale, which is laced with word-play and riddles, the young boy displays his insightfulness and moral character, and in the process touches on matters related to traditional Chinese cosmology and popular lore as well. An appendix to the story identifies the disciples of Confucius by name, according to their degrees of closeness to him.

Most expanded versions of *tongsheng* have depictions of, and texts related to, the 'Emperor of the Four Seasons,' as well as illustrations, often personified, of the primary asterisms of the 28 lunar lodges. They usually contain pictures of the 26 dangerous 'passes' encountered by children, and often include the 'Baked Pastry Song' of Liu Bowen as well. Other word-related material regularly found in Hong Kong almanacs are charts showing 100 ways to write auspicious Chinese characters such as *fu* (blessings) and *shou* (longevity), and examples of four different calligraphic styles used to render the *Qianzi wen* (Thousand Character Essay), a famous Confucian text which never repeats a character (Fig. 4.3). Such entries offer evidence of the continued

70

4.3. Four different calligraphic styles for the first 32 characters of the 'Thousand Character Essay.' From a Hong Kong almanac for 1986. 18 cm. x 10.5 cm.

significance of 'word-magic' and calligraphy in traditional Chinese culture.

Large almanacs invariably contain an enormous amount of material on divination. Like their counterparts from the imperial era, such *tongsheng* provide elaborate lists of auspicious and inauspicious star spirits for convenient reference in matters pertaining to day selection. They also supply several overlapping (though not always entirely consistent) systems of numerology that go by names, and

involve techniques, not generally found in late Qing almanacs. 'The Secret Book of Zhuge [Liang]'s Spiritual Calculation', for example, uses the number of strokes contained in each of three written characters to determine one of 384 interpretive possibilities. Another numerologically grounded system, identified with the legendary diviner Yuan Tiangang, offers individualized predictions based on the spiritual 'weight' of a person's eight characters. In neither instance, however, do we find a significant departure from conventional cosmological assumptions.

Despite some new material, the vast majority of mantic techniques in contemporary *tongsheng* can be traced directly to Qing dynasty almanacs. These include *zhoutang* calculations of various sorts, *Yijing*-related coin-tossing procedures, the use of divining block texts, the interpretation of spiritual sticks, physiognomy, the analysis of personal omens, and the evaluation of dreams by means of the *Zhougong jiemeng*. In each case, the texts and illustrations in *tongsheng* bear a remarkably close resemblance to those found in Qing almanacs, down to the depiction of imperial-style coins (rather than those of the Republic) for coin divination (Fig. 4.4). The primary difference between the two types of almanacs is in the quality of print, which is better, by and large, in modern Hong Kong.

Although most almanacs produced in Hong Kong assume a basic understanding of the specialized vocabulary of divination, at least a few works now acknowledge the need to provide explanations for technical terms, such as those used to designate auspicious and inauspicious activities in day-charts. Thus, the expression *titou* (literally, to shave the head) is explained as having two different meanings: one, the first haircut of a newborn child; and two, the shaving of one's head for the Buddhist priesthood. Likewise, depictions

此卦向南方
第六稼穡卦平平
未謀有吉
出行平平

船放江湖內
第五炎上卦下下
喜意得利
謀事可成
災危不可當
婚姻不成

動作因風便
第四潤下卦小平
謀事先成
灘邊護寶珍
求財八分
病人安

從革宜更變
第三曲直卦下平
求官小就
謀事有成
求謀可託人
訟事宜和
病人無妨

彩鳳呈祥瑞
第二從革卦上平
求官得位
考試如意
麒麟降帝都
時來合動遷
訟事有和
病人無妨

金錢卦
第一星震卦上上
求官得位
考試如意
訟事有理
病即安寧
禍除通福至
求財十分
尋人得見

官司多不利
訟事無理
尋人不見

若逢戊已土
求財不多
尋人不遇

更宜將大用
求財有吉
尋人得遇

龍門魚躍過
求財八分
走失有望

目下有災映
行人不至

事事得遂心
婚姻可成
交易有功

災歇福來居
婚姻有成
交易有利

凡骨作神仙
婚姻百成
交易有功

喜氣自然舒
婚姻得成
買賣十分

4.4. The coins depicted in this Hong Kong almanac (1991) are from the Guangxu period (1875–1908) of the Qing dynasty. 17 cm. x 10 cm. The system of coin divination represented, one of several employed in China for over a thousand years, had close counterparts in Qing dynasty almanacs.

of dangerous passes now carry concrete advice on what to be aware of in any given situation, and exactly what to do about it. All this suggests a certain loss of cultural memory on the part of Hong Kong almanac users. For similar reasons, a semi-classical text such as the 'Family Regulations of Master Zhu' must now be glossed heavily for most modern readers to understand it. Yet despite these interpretive difficulties, and probably in part because of these devices, *tongsheng* remain popular not only in Hong Kong, but also in overseas Chinese communities throughout the world. Moreover, they

have found their way in considerable numbers to south China, where Cantonese-speaking Mainlanders continue to use them for lack of a satisfactory alternative.

Taiwan Almanacs

The situation is different in Taiwan. There, Mandarin serves as the official dialect and many people trace their ancestry directly to Fujian province. Thus Fujian-style almanacs tend to be preferred over the Cantonese type. Significantly, however, one can find in cities such as Taipei almanacs designed with Cantonese clients in mind. These bear the characters *gangshi* on the covers, indicating that they have been put together according to the 'Hong Kong style' and by the same token, at least a few Taiwan-style almanacs can be found in Hong Kong.

Although all almanacs produced in Hong Kong and Taiwan share the same basic cosmology, not to mention a number of specific features, those published on Taiwan can easily be distinguished from their Cantonese counterparts. In the first place, they are infinitely more varied in content. One important reason is that the island province lacks a single calendrical authority analogous to Cai Boli in Hong Kong. Taiwanese almanacs also differ markedly in style and appearance from one another. Some look simple and quaint, rather like comic books, while others contain relatively few illustrations and are full of esoteric texts and charts. The former are generally called 'people's almanacs' (*minli*) while the latter go by a name that suggests an almanac 'reference work' (*tongshu bianlan*).

Most *tongshu bianlan* identify themselves with specific individuals, who, in turn, claim descent from traditions of almanac-making that originated long ago on the Chinese

mainland. Perhaps the most famous of these individuals in contemporary Taiwan is Lin Xianzhi of Taizhong, who considers himself part of a line of transmission begun by the illustrious Hong Chaohe of Fujian province some 200 years ago. Serious students of almanac-making on Taiwan tend to consider Lin's work to be the most accurate and comprehensive of its kind. Although some of Lin's competitors, such as Lü Fengyuan and Gao Mingde, both of whom reside in Taipei, also claim to share a relationship with the tradition of Hong Chaohe, their almanacs acknowledge other calendrical and divinatory traditions as well.

At first glance, *tongshu bianlan* look substantially the same. They all have solid red covers with black print (plate 13). They are about the same size, have approximately the same number of pages, and their day-charts seem uncannily similar in general appearance (plate 14). All share the same basic features, including a cosmograph akin to the *liunian shikuan* of Qing times, a description of the 'spring ox' and herdsman, excerpts from the *Dimu jing*, charms, numerological charts based on stem-branch combinations, and various standard divination systems. Much of the cosmological information conveyed in this material is the same in almanacs of all types, whether produced in Taiwan or Hong Kong. Thus, for any given year, the *liunian* chart, description of the spring ox and herdsman, and *Dimu jing* prognostications are essentially the same on both sides of the Taiwan Strait.

On the other hand, the order in which charts, excerpts, charms and mantic systems appear in Chinese almanacs differs substantially—not only between Taiwan *tongshu* and Hong Kong *tongsheng*, as might well be expected, but also between different types of almanacs, and even between *tongshu* of the same basic variety. A comparison of the day-

charts of the *tongshu bianlan* by Lin, Gao and Lü, for example, reveals no precise agreement regarding which activities are lucky or unlucky for any given day. There is, to be sure, a substantial overlap, but seldom an exact fit, even when the almanac-makers specify, as they often do, the traditional textual authority on which they have based their predictions.

Like some Qing and early Republican-era almanacs, but unlike Hong Kong *tongsheng*, Taiwan *tongshu* generally contain introductory essays explaining the complicated process of selecting auspicious and inauspicious activities for inclusion in day-charts. They also provide personal prefaces, which standard Hong Kong almanac-makers eschew entirely. In the case of *tongshu bianlan*, a statement by the author establishing his credentials seems obligatory, along with a long list of colleagues and collaborators. But some Taiwanese almanac-makers also seek endorsements from officials in the fashion of Qing *tongshu*. Lin's work, for instance, contains prefaces written by several leading government figures, including Cai Hongwen and Lin Yanggang. As with almanac-makers in the Qing period and Republican era, all major compilers of *tongshu bianlan* in Taiwan seek to identify themselves unambiguously with the regime, and all display a version of the same phrase at the beginning of their day-charts: 'Long live the Republic of China'.

For similar political reasons, popular almanacs also yearn for identification with the State. Although some carry personalized titles, such as 'The People's Calendar of Jin Taibo', or the 'The People's Calendar of Tiebizi', a number refer to themselves as 'The People's Calendar of China', or the 'Peasant Calendar of China'. Significantly, the day-charts of these works usually begin on 1 January—the initial day of

the 'national [solar] calendar'—rather than on the lunar 'first day of spring', as with most other *tongshu* and *tongsheng* (plate 15). Yet despite these efforts to show loyalty to the regime, *minli* can never hope for any sort of legitimization from public officials. From an elite perspective such works are simply too 'crude' to warrant testimonials.

Because of their diversity, generalizations about 'people's almanacs' are especially difficult to make. Aside from the common demominators of *liunian* charts, descriptions of the spring ox and herdsman, and excerpts from the *Dimu jing*, these works bear little resemblance to one another— and even less to *tongshu bianlan*. All, however, contain colourful charms (plate 16) and boast striking covers which, like those of Cantonese *tongsheng*, draw upon a vast symbolic repertoire. These covers tend to display the zodiacal animal of the year, felicitous phrases such as 'Happy New Year' or 'Wealth from All Directions', and magical signs, such as the *Taiji tu* surrounded by the eight trigrams, or auspicious depictions of dragons, cranes, fish, peaches or cherubic children, sometimes in combination. Such covers also often have pictures of happy families, Chinese cultural heroes, or deities such as the God of Wealth, the God of Longevity, the Goddess of Mercy (Guanyin), or the Buddha of the Future (Maitreya; Mile Fo) (plates 17, 18 and 19). Predictably, almanacs with overtly 'religious' covers usually have the most obviously religious content.

Minli include the same basic divinatory systems that can be found in most traditional-style Chinese almanacs— numerology, fate extrapolation, geomancy, physiognomy, portent interpretation, dream analysis, and so forth. A number, however, boast additional techniques that seem distinctive to works published in Taiwan. One of these involves calculating the annual fate of China as a whole.

Thus we find 'The People's Calendar of Tiebizi' for 1989 predicting dramatic political changes in both Taiwan and the People's Republic of China (or, as the almanac refers to it, 'the bogus Mainland government'). As we know, the prophecy came to pass. Although the transformation of Taiwan's political system was less cataclysmic than the events surrounding the infamous 'Tiananmen Incident', both developments seemed to validate the previous year's predictions—as the foreword to the 1990 edition of the almanac takes obvious pride in pointing out.

Among other divination techniques not to be found in almanacs outside Taiwan are flow charts showing how the 'rhythms of fate' fluctuate throughout the year for individuals born in each of the 12 years of the Chinese zodiac, as well as predictions based on different configurations of incense sticks placed in incense burners. For reasons that are not entirely clear, but which may have to do with issues of divinatory authority, Taiwan almanacs, both *minli* and *tongshu bianlan*, use the symbolism of the *Yijing* far more frequently than almanacs from other areas of China and other periods of time.

Taiwan almanacs of all kinds serve as recepticles for traditional Chinese culture. A few *minli* may stoop to introducing one or another system of foreign divination; and some might even go so far as to use Western-looking faces to illustrate Chinese physiognomic principles. But on the whole, almanacs published in Taiwan today include less explicitly foreign material than those of the late Qing period, the early Republican era, or even contemporary Hong Kong. Instead of slavishly imitating the West, many almanac-makers on Taiwan react strongly against it. Jin Taibo's 'People's Calendar' for 1990, for instance, emphasizes that almanacs are one of China's 'ancient cultural artefacts', and that such traditionally grounded works provide guidance for Chinese

people everywhere and at all times. Occasionally the connections made in such works between divination, the traditional cosmology and the inherited culture are quite fascinating. In one almanac, for instance, an extensive chart on the relationship between the five 'elements' and traditional Chinese naming practices reveals that among various luminaries possessing the 'wood' radical in their given names are: Pu Songling, the early Qing author; Ding Baozhen, the late Qing reformer; and Sima Xiangru, the Han dynasty poet— all conveniently identified for readers in the text.

Somewhat surprisingly, almanacs published in Taiwan seldom contain morality tales of the sort commonly found in full-sized *tongsheng*—this, despite the self-conscious promotion of traditional values by the contemporary Nationalist government. Generally speaking, neither *tongshu bianlan* nor *minli* carry stories such as the 'Twenty-four Paragons of Filial Piety' or the encounter between Confucius and the precocious young boy. Perhaps the reason is that these stories appear less necessary because government support of the traditional value system is so substantial. Although some Taiwan almanacs devote considerable attention to religious themes, these discussions often read more like justifications of spirituality against the charge of 'superstition' than moral tracts per se. Discussions of mantic techniques, particularly geomancy, in almanacs suggest a similar sensitivity, evident in efforts by some authors to demonstrate the 'scientific' nature of *fengshui*.

Judging from the content of popular almanacs (and *tongshu bianlan* as well), it appears that the loss of cultural memory on Taiwan may be somewhat more acute than in Hong Kong. Although in both places publishers find it increasingly necessary to explain the special terms used in day-columns, Taiwan almanacs seem to devote inordinate space to

explanations of what contemporary *tongsheng* in Hong Kong, not to mention *tongshu* from the late Qing and early Republican periods, could always take for granted—basic knowledge of stem-branch calculations, solar periods, various divination techniques, and so forth. Ironically, however, these concessions to the modern temper in Taiwan (if that is what they are), probably contribute to a more uniform understanding of the symbolism and substance of traditional Chinese almanacs than ever existed before.

Conclusion

How, in the end, do we account for the remarkable staying power of Chinese almanacs? One obvious answer is their demonstrable utility. For some 2,000 years they have served practical purposes rather than merely supplying amusement. Unlike their Western counterparts over the past two centuries or so, traditional Chinese almanacs have never relied upon humour or idle chatter to attract an audience. Some readers today no doubt consider the day-columns and divination systems of old-style *tongshu* and *tongsheng* to be a form of entertainment, analogous perhaps to the horoscopes found in certain Western newspapers, but a great many Chinese continue to take the divinatory assumptions of almanacs seriously, particularly in Taiwan and Hong Hong. To these individuals, the ancient notion of a spiritual resonance between Heaven and Man, which lies at the heart of Chinese mantic beliefs, remains attractive and entirely plausible. This view, one might argue, is no less rational, and therefore no more incompatible with the principles of modern science, than the Western faith in a single, transcendant God.

In purely psychological terms, we know that charms, geomantic manipulation of the environment, and the optimistic thrust of techniques such as 'spiritual stick' divination and dream book interpretation, provided (and still provide) the Chinese with hope and courage in times of uncertainty and fear. Since traditional-style almanacs have long emphasized these forms of cosmic empowerment and personal reassurance, we may profitably think of them as inspirational 'self-help' books for individuals facing difficult situations. At the same time, the practical advice of almanacs

in realms such as agriculture, food, health care, and ceremonial usage, inspired confidence in other ways.

From another standpoint, traditional Chinese almanacs, like calendars, contributed to social stability by regulating the rituals and rhythms of daily life. To this day they provide an inexpensive and reliable way of marking time, indicating seasonal changes, and identifying important dates for celebrations and other ceremonial observances. Few devices have been more powerful as mechanisms for structuring social behavior than the stipulations in *tongshu* regarding popular festivals, birth and death anniversaries, and lucky or unlucky days. Although in imperial times the day-columns of State calendars and unofficial almanacs did not always agree in particulars, there was enough overlap to sustain public faith in an ordered, predictable universe. Similarly today, discrepancies between different types of *tongshu* on Taiwan, or between these works and *tongsheng* in Hong Kong, are not so glaring as to undermine the foundations of popular belief.

The longevity of Chinese almanacs can also be explained in purely cultural terms. Their explicitly moral cast, for example, has always resonated powerfully with the Middle Kingdom's ancient self-image as 'the land of ritual and right behavior' (*liyi zhi bang*). Although almanacs published by the State on the Mainland since 1949 are naturally devoid of all religious elements and most traditional Confucian values, they are still full of moral admonitions. The socialist ethical message may not be the same as in pre-liberation times, but the didactic medium certainly is.

Finally, almanacs have had an enduring aesthetic appeal. For all the changes they have undergone, their traditional symbolism has remained substantially the same. It is true, of course, that the symbolic repertoire of State-sponsored

almanacs on the Mainland has shrunk appreciably; but in even the most ideological of these publications we find certain forms of traditional imagery, such as a predominance of the colour red, or the positive symbolism of fish (abundance) and happy children.

From the standpoint of history, almanacs have provided a convenient means of becoming 'modern' yet remaining 'Chinese'—particularly after the trauma of 1895. When new ideas came to China at the end of the Qing period, almanacmakers were quick to incorporate them, especially in comparatively progressive treaty-port areas. At the same time, however, the traditional ethics, symbolism, and cosmology of old-style *tongshu* remained by and large intact. Paradoxically, the almanacs in present-day Hong Kong and Taiwan are generally more conservative in content than the almanacs of the early twentieth century. At least they have less material of obviously Western inspiration. One reason may well be that information about the West that was so startling to the Chinese in 1905 is no longer news, and now can easily be found in any number of places. But perhaps another reason is that traditional-style almanacs provide a way of linking individuals with a past that in some, if not many, ways seems superior to modernity. These works, in other words, may represent a conscious effort on the part of their sponsors (and their audience), to hold on to selected aspects of China's 'great tradition'—features that are imperilled, but seem worthy of retention.

What does the future hold? From all appearances, traditional-style almanacs will continue to flourish on Taiwan, as well as in Hong Kong—at least until 1997. When Hong Kong reverts to Mainland rule, however, the question must naturally arise: Will the People's Republic allow private firms to continue publishing traditional-style almanacs? In

the interest of cultural continuity I would hope so, although the history of almanacs in the People's Republic is not particularly encouraging on this score. Clearly, much depends on how the Mainland government evolves over the next five years, and what its attitude will be toward traditional Chinese culture. My own view is that experience in Taiwan and Hong Kong demonstrates conclusively that a 'modern' economy can coexist with a 'traditional' culture, and that Mao's concerted effort to attack the past indiscriminately in the name of socialist 'progress' was wrong-headed.

In short, traditional-style almanacs, as living relics of a glorious and still vital past, can play an important role in perpetuating certain elements of Chinese culture. They thus have a dual educational role to play in Chinese environments—as conduits of new information, and as receptacles of enduring symbols, spiritual beliefs, moral values and social attitudes. As in the past, Chinese almanac-makers should be allowed to let the market dictate the content of their work, and if the past has no value, old-style almanacs will die a natural death. So be it. The important point is that the option of holding on to traditional Chinese culture should remain alive.

Glossary

TERMS

bazi 八字	eight characters of a person's birth
buyi 不宜	inappropriate
dali 大曆	'great calendar'
dao 道	the Way
daquan 大全	comprehensiveness
dashi 打時	'hitting the time'
dili 地理	earthly configurations; geography; geomancy
Ershisi xiao 二十四孝	the 'Twenty-four Paragons of Filial Piety'
fengshui 風水	geomancy
fu 福	blessings
fu 符	charms
gangshi 港式	'the Hong Kong style'
guan 冠	'capping', a ceremony marking the adulthood of a male
guan 關	pass
guoli 國曆	'national calendar'
huangli 皇曆	imperial calendar
ji 吉	auspicious
ji 忌	inappropriate; avoid
jianchu 建除	system of determining good and bad fortune in calendars and almanacs
jiaobei 珓杯	divining blocks
jing 精	vital essence
jing 井	well
jiugong 九宮	the 'Nine Palaces' of Chinese cosmology
lingqian 靈籤	'spiritual sticks', used for divination
liri 曆日	almanac
lishu 曆書	almanac
liunian dali 流年大利	cosmological table for almanacs based on the *jiugong* system

liunian shikuan 流年事款	same as *liunian dali*
liyi zhi bang 禮義之邦	'land of ritual and right behavior'
mangshen 芒神	the 'herdsman' of Chinese almanacs
minli 民曆	'people's calendars'
mixin 迷信	superstition
nayin 納音	a cosmologically-based system of calendrical calculation
nianshen fangwei zhi tu 年神方位之圖	cosmological table for calendars based on the *jiugong* system
po mixin 破迷信	'destroy superstition'
qi 氣	material force
qian 籤	see *lingqian* above
Qianzi wen 千字文	the 'Thousand Character Essay'
rishu 日書	almanac
riyong bianlan 日用便覽	encyclopedias of daily use
sha 煞	evil spirit
Shaobing ge 燒餅歌	'Baked Pastry Song'
shen 神	benevolent spirit
sheng 聖	sage
sheng 勝	to win
shentong 神童	the 'herdsman' of Chinese almanacs
shou 壽	longevity
shu 書	book
shu 輸	to lose
Siji huangdi 四季皇帝	'Emperor of the Four Seasons'
sili 私曆	'private calendars'
Taiji 太極	the Supreme Ultimate
Taiji tu 太極圖	'Diagram of the Supreme Ultimate'
Tianguan sifu 天官賜福	'The Conferral of Blessings by the Heavenly Official'

tianwen 天文 patterns in the sky; astronomy; astrology
tongsheng 通勝 almanac
tongshu 通書 almanac
tongshu bianlan almanac 'reference-work'
通書便覽
tongshu xuanze 'almanac selection'
通書選擇
wenming 文明 civilization
wuxing 五行 the five 'phases', 'elements' or 'activities'
xiaoli 小曆 'small calendars'
xiong 凶 inauspicious
xinli 新曆 'new calendar'
xin tongshu 'new almanac'
新通書
xiu 宿 lunar lodges
yang 陽 cosmic force; male
yi 宜 appropriate
yin 陰 cosmic force; female
yuyong 御用 'imperial use'
zhoutang 周堂 a circular device used for divination

BOOKS CITED IN THE TEXT

Bianmin tongshu 便民通書

Jubaolou tongsheng 聚寶樓通勝

Datong li 大統曆

Daquan qizheng tongshu 大全七政通書

Daquan tongshu 大全通書

Dimu jing 地母經

Gongyuan yijiu baba nian wuchen lishu 公元一九八八年戊辰曆書

Guanshang bianlan 官商便覽 (*see* Yingxue zhai guanshang
bianlan wubai zhong)

Guanshang kuailan 官商快覽

Hua'nan tongshu 華南通書

Jixiang ruyi tongshu 吉祥如意通書

Liwen tang zouji tongshu 利文堂諏吉通書

Lin Xianzhi tongshu bianlan　林先知通書便覽

Riyong bianlan　日用便覽

San Fo yingjie tongguan tongshu　三佛應劫統觀通書

Shixian li　時憲曆

Shixian shu　時憲書

Tianbaolou jiqi hongzi tou tongshu　天寶樓機器紅字頭通書

Tiebizi minli　鐵筆子民曆

Wannian li　萬年曆

Woguo minli　我國民曆

Xiantian bagua tu　先天八卦圖

Xinhai guanshang kuailan　辛亥官商快覽

Xuanze tongshu　選擇通書

Yijing　易經

Yingxue zhai fenlei guanshang bianlan wubai zhong
映雪齋分類官商便覽五百種

Zhongguo minguo shiqi nian suici wuchen yinyang heli tongshu
中國民國十七年歲次戊辰陰陽合曆通書

Zhongguo minguo shisi nian liben　中國民國十四年曆本

Zhongguo minli　中國民曆

Zhougong jiemeng　周公解夢

Zhougong jiemeng quanshu　周公解夢全書

Zouji bianlan　諏吉便覽

Zouji tongshu　諏吉通書

Selected Bibliography

Bredon, Juliet and Igor Mitrophanow, *The Moon Year: A Record of Chinese Customs and Festivals* (Shanghai, 1927).

Burkhardt, V. R. *Chinese Creeds and Customs* (Hong Kong, 1953–8; esp. Vol. 2 [1955]).

Capp, Bernard, *English Almanacs, 1500–1800: Astrology and the Popular Press* (Ithaca, New York, 1979).

Chang, Hsueh-yen, 'The Lunar Calendar as a Social Control Mechanism in Chinese Rural Life' (Ph.D dissertation in Sociology, Cornell University, 1940).

De Groot, J. J. M., *The Religious System of China* (Leiden, 1892–1910).

Doré, Henri, *Researches into Chinese Superstitions* (Shanghai, 1914–33).

Douglas, Robert K., *China* (London, 1882).

Gao Pingzi, *Xueli sanlun* (Miscellaneous Studies on the Calendar; Nangang, Taiwan, 1969).

Ho, Peng-Yoke,'The Astronomical Bureau in Ming China', *Journal of Asian History*, 3 (1969).

Hoang, Pierre, *A Notice of the Chinese Calendar* (Zi-ka-wei [Shanghai], 1904).

Hong Jixi , *Chuanzhou Hongshi bainian li* (One Hundred Year Calendar of Mr. Hong [Chaohe] of Quanzhou; Fujian, 1981).

Kudo, Motoo, 'The Ch'in Bamboo Strip *Book of Divination* (*Jih-shu*) and Ch'in Legalism', *Acta Asiatica*, 58 (1990).

Kuhnert, Franz, 'Der Chinesische Kalender', *T'oung-pao*, 2.1 (1891).

Kulp, Daniel, *Country Life in South China* (New York, 1925).

Kwok, Man-ho, *The Chinese Almanac 1990* (Toronto, New York, London, etc., 1989).

Lister, Alfred, 'Chinese Almanacs', *China Review*, 1 (1872–3).

Martin, W. A. P., *A Cycle of Cathay* (Edinburgh and London, 1897).

Milne, William, *Retrospect of the First Ten Years of the Protestant Mission to China* (Malacca, 1820).

Milne, William, *Life in China* (London, 1858).

Morgan, Carole, *Le tableau du boeuf du printemps: Étude d'une page de l'almanach chinois* (Paris, 1980).

Morgan, Carole, 'De l'authenticité des calendriers Qing,' *Journal Asiatique*, 271.3–4 (1983).

Palmer, Martin, *T'ung Shu: The Ancient Chinese Almanac* (Boston, 1986).

Parker, A. P., 'The Chinese Almanac', *Chinese Recorder*, 19.2 (1888).

Smith, Richard J., 'A Note on Qing Dynasty Calendars', *Late Imperial China*, 9.1 (June, 1988).

Smith, Richard J. *Fortune-tellers and Philosophers: Divination in Traditional Chinese Society* (Boulder, Colo., and Oxford, England, 1991).

Smith, Richard J., *et al.*, eds., *Robert Hart and China's Early Modernization: His Journals, 1863–1866* (Cambridge, Mass., 1991).

Stowell, Barbara, *Early American Almanacs* (New York, 1977).

Tang Hanliang, *Nongli ji qi biansuan* (The Farmer's Almanac and Its Compilation; Nanjing [?], 1977).

Topley, Marjorie, ed., *Some Traditional Chinese Ideas and Conceptions in Hong Kong Social Life Today* (Hong Kong, 1967).

Wang Ping, *Xifang lisuan xue zhi shuru* (The Introduction of Western Calendrical Science [to China]; Nangang, 1966).

Williams, Samuel W., *The Middle Kingdom* (New York, 1883).

Zheng Tianjie, *Lifa congtan* (Collected Discussions of Calendrical Methods; Taipei, 1977).

Zhu, Wenxin, *Lifa tongzhi* (Complete Account of Calendrical Methods; Shanghai, 1934).

Index